IMAGES
of America

BILTMORE ESTATE

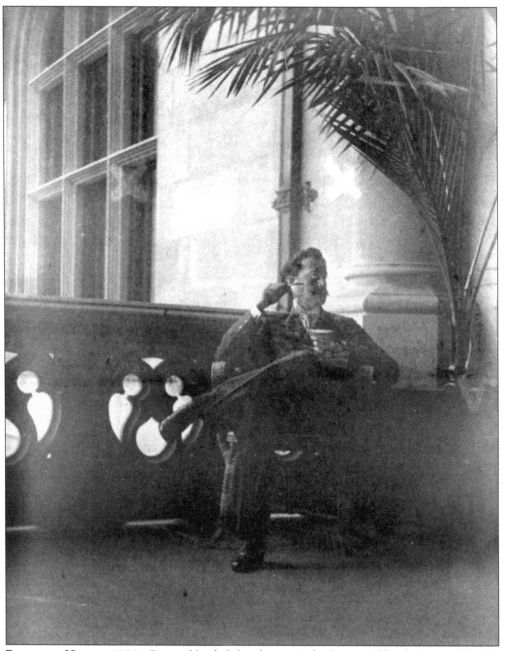

BILTMORE HOUSE, 1900. George Vanderbilt relaxes on the Loggia of his home in Western North Carolina.

IMAGES
of America

BILTMORE ESTATE

Ellen Erwin Rickman

ARCADIA
PUBLISHING

Published by Arcadia Publishing
Charleston, South Carolina

Library of Congress Catalog Card Number: 2004112566

For all general information contact Arcadia Publishing at:
Telephone 843-853-2070
Fax 843-853-0044
E-mail sales@arcadiapublishing.com
For customer service and orders:
Toll-Free 1-888-313-2665

Visit us on the Internet at www.arcadiapublishing.com

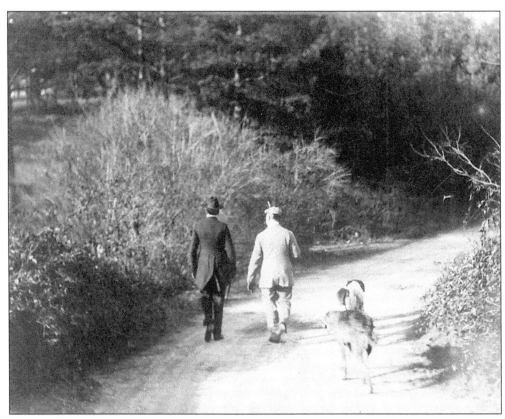

GEORGE VANDERBILT, 1906. An unidentified friend (on the right) explores Biltmore Estate with Mr. Vanderbilt and his pet St. Bernard and Irish wolfhound.

CONTENTS

ACKNOWLEDGMENTS

I am indebted to my stellar editing team from Biltmore Estate—Landscape and Forest Historian Bill Alexander, Associate Curator of Interpretation Susan McKendree, and Curator of Collections Darren Poupore for their assistance. I am also thankful for the support I received from Special Collections Manager Suzanne Durham and Museum Services Administrative Assistant Patty Grear. Most of all, I am grateful to all of my colleagues at Biltmore for their commitment to preserving Biltmore Estate and their enthusiasm for sharing Biltmore's unique story with others.

INTRODUCTION

Attracting hundreds of thousands of guests per year, Biltmore Estate in Asheville, North Carolina, is one of the most highly visited historic sites in the United States. Since its inception in the late 1880s when American millionaire George Washington Vanderbilt's grand plans for his estate first became known, Biltmore Estate has fascinated young and old alike. That fascination is fueled by the fact that Biltmore's founder was a very private man. Mr. Vanderbilt quietly set about to create not only a monument to wealth and personal comfort but, more importantly, to use his wealth in responsible and respectful ways, such as introducing innovative land management practices and contributing to artistic, educational, and spiritual communities. In these pages, details about the creation of Biltmore Estate and the lives of its residents are revealed through historic photographs selected from the rich and diverse Biltmore Estate photograph collection—many of which have never before been published.

George Washington Vanderbilt (1862–1914) first visited Western North Carolina in early 1888. Like many others, he was attracted to the area because of its reputation for having a healthy climate. According to his friend Charles McNamee, the natural mountain scenery and mild weather so delighted Vanderbilt that he planned a return trip and invited McNamee to accompany him. On May 1, 1888, as Vanderbilt and McNamee rode their horses through the hills surrounding Asheville, they came upon a captivating view of mountain vistas. At the site where Biltmore House now stands, Vanderbilt expressed to McNamee his desire to build a home at that very location. Vanderbilt's wish soon became McNamee's charge: Vanderbilt hired McNamee, an attorney by profession, to begin purchasing tracts of land on his behalf. By the end of the year, McNamee had purchased 2,000 acres, a figure that would grow to mammoth proportions by Vanderbilt's death in 1914, when he owned approximately 125,000 acres of land stretching over four counties.

Vanderbilt's intent in acquiring so much land became clear within a few short months of his first visit to the area. He hired landscape architect Frederick Law Olmsted and architect Richard Morris Hunt to create a home in the southern mountains that would complement the two homes he already owned, one on Fifth Avenue in Manhattan and another on the coast at Bar Harbor, Maine. Though both Olmsted and Hunt were renowned masters in their fields, no one could anticipate what they and Vanderbilt would ultimately produce: a grand estate in the European country house tradition. At the heart of the estate was Biltmore House, a masterpiece in American architecture filled with fine furnishings, rare books, and priceless art from around the world. Surrounding Biltmore House were artfully landscaped gardens within a naturalistic

mountain landscape, working farms and scientifically managed forests that provided income to support estate operations, a model village just outside the estate's entrance, and a rustic lodge on the highest nearby peak.

Who was George Vanderbilt? Born in New York City in 1862, he was the son of railroad tycoon William Henry Vanderbilt and grandson of "Commodore" Cornelius Vanderbilt. The Commodore was a larger-than-life figure who established the family's fortune in transportation and created a financial empire that made the Vanderbilts one of the wealthiest families in the world. The youngest of William Henry and his wife Maria Louisa's eight children, George spent much of his childhood and early adulthood visiting museums, libraries, and historic sites around the world. He was fascinated by what he experienced, and in his travels he gained a passion for collecting that would last a lifetime. His artistic and intellectual interests found ultimate expression in the creation of Biltmore Estate.

For almost 20 years, Biltmore Estate served as George Vanderbilt's primary residence. Vanderbilt was a 33-year-old bachelor when he first welcomed family and friends to Biltmore House in 1895. This fact generated a great deal of rumor and speculation in the press: Why would a young single man create such a mansion if he did not intend to marry and have a family? In 1898, the question of whether Vanderbilt would ever marry was answered when he wed Edith Stuyvesant Dresser, a young woman from a prominent New England family, in a private ceremony in Paris. Mrs. Vanderbilt soon became known as "the mistress of Biltmore." She was the perfect complement to her husband, taking on the role of hostess in Biltmore House, providing support for the families of estate workers, and taking an active role in providing educational opportunities for both children and adults. The birth of daughter Cornelia Stuyvesant Vanderbilt, or "Tarheel Nell" as she was often called in the press because of her North Carolina origins, made George and Edith's family complete. Cornelia grew up on Biltmore Estate and, once married with her own family, continued the traditions of hospitality established by her parents.

In the creation of Biltmore Estate, George Vanderbilt set an example for the entire nation in progressive and self-sustaining land management practices. Secretary of Agriculture J. Sterling Morton best summed up the significance of Vanderbilt's contributions in 1896 when he wrote, "I feel like thanking old Commodore Vanderbilt for having given us a grandson who has the brains and the benevolence to devote his wealth to afford the public such valuable lessons in art, architecture, forestry, viticulture, dairying, road-making and other useful sciences" ("George Vanderbilt and His Southern Work," *The Lyceum*, March–April 1896, p. 20). George Vanderbilt's visionary approach lives on today in his descendants, who own and operate Biltmore Estate and whose mission is the preservation of Biltmore Estate as a private, profitable working estate.

One

A FAMILY ALBUM

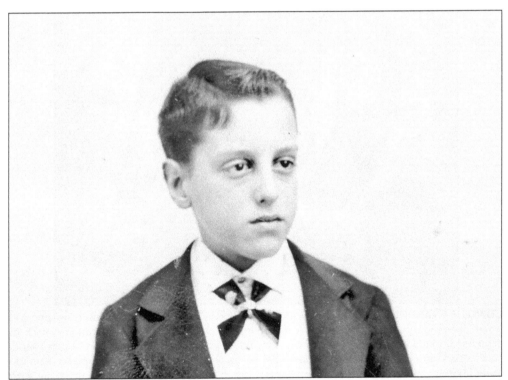

GEORGE WASHINGTON VANDERBILT, C. 1873. Young George (1862–1914) had tutors and attended private schools in New York City, where he took the standard course of study: French, mathematics, classical studies, history, and music. Unlike most boys, however, he also got a first-hand education. He traveled extensively in both the United States and Europe, where he visited famous museums and historic sites, attended the theater and opera, and met important artists and writers.

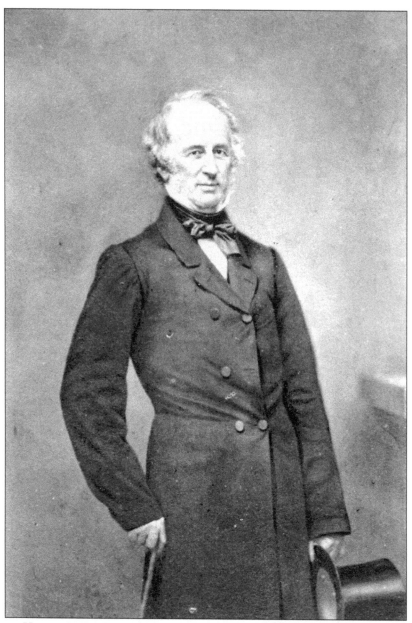

CORNELIUS VANDERBILT, "THE COMMODORE," C. 1870. The founder of the family fortune and a man of legendary qualities, Cornelius Vanderbilt (1794–1877) was a sixth-generation American descended from a long line of farmers who originated in Holland and settled in Staten Island, New York. Cornelius set his own course in life when, at the age of 16, he purchased a boat and ferried both people and goods back and forth between Staten Island and Manhattan. He soon caught the attention of one of the first steamship owners in the region, who hired Cornelius as a steamer pilot. Cornelius's superb nautical skills earned him the honorary title "The Commodore." In 1829, Cornelius Vanderbilt began building his own line of steamships. The Commodore ultimately established the Vanderbilts as America's wealthiest family by creating a transportation empire in shipping and railroads. When he died in 1877, he left behind over $100 million, most of which he left to his eldest son, William.

WILLIAM HENRY VANDERBILT AT HIS MANHATTAN HOME, C. 1882. Though William H. Vanderbilt (1821–1885) was more reserved and intellectual than his father, the Commodore, he was equally adept at business. William Vanderbilt succeeded his father as president of the New York Central Railroad and expanded the family's business interests and wealth considerably. When he died in 1885, William Vanderbilt's fortune was worth over $200 million, the equivalent of almost $4 billion today.

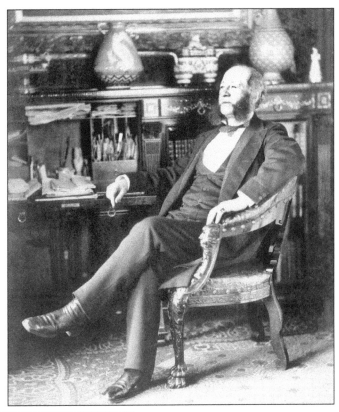

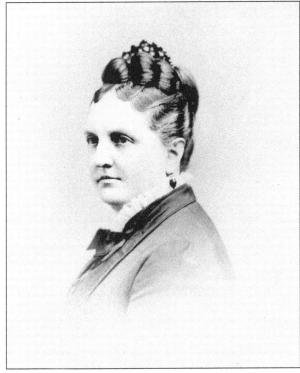

MARIA LOUISA KISSAM VANDERBILT, C. 1870. Mrs. Vanderbilt (1821–1896), the daughter of a prominent New York minister, married William H. Vanderbilt in 1841. George, the youngest of Mr. and Mrs. Vanderbilt's children, was very close to his mother. When Biltmore House was first completed in 1895, she served as hostess to family and friends who visited the estate over the Christmas holidays.

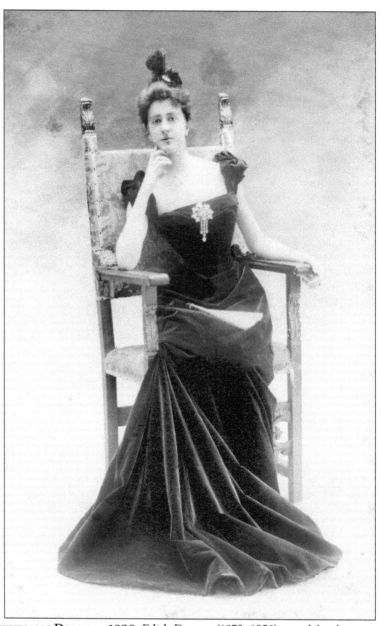

EDITH STUYVESANT DRESSER, 1898. Edith Dresser (1873–1958) posed for this portrait in Paris after the announcement of her engagement to George Vanderbilt. Edith's ancestors were some of the most influential figures in early American history. They included Peter Stuyvesant, the first Dutch governor of New York, and Nicholas Fish, a prominent Federalist. When Edith was a child, both of her parents died within a few weeks of each other; therefore, her maternal grandparents raised her and her siblings in Newport, Rhode Island. Like George, Edith was cosmopolitan, dividing her time after her grandparents' deaths between New York and Paris. Edith Dresser and George Vanderbilt were members of the same fashionable society in New York and Newport. Though they both attended a house party at George's sister Lila Vanderbilt Webb's home in the early 1890s, their courtship did not begin until 1897, when they were passengers on the same ship crossing the Atlantic Ocean from New York to Southampton, England.

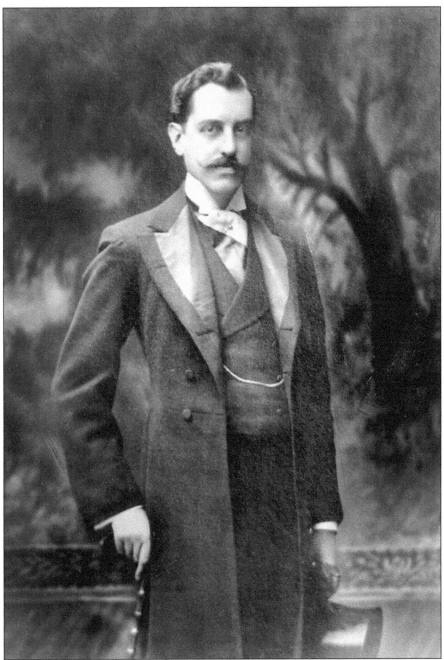

GEORGE VANDERBILT, C. 1898. This portrait of George Vanderbilt was taken in Paris around the time of his marriage to Edith Dresser. Following French law, George and Edith Vanderbilt were first married on June 1 in a civil ceremony. They wed the following day in a religious ceremony at the American Cathedral in Paris with most immediate family members and a small number of friends in attendance. George Vanderbilt's best man was William Bradhurst Osgood Field, a close friend who later married George's niece Lila Sloane. LeRoy Dresser, Edith's brother, escorted her down the aisle, while two of her close friends served as bridesmaids. George and Edith honeymooned in Stressa, Italy, in a rented villa overlooking Lake Maggiore.

CORNELIA STUYVESANT VANDERBILT, 1902. George and Edith Vanderbilt's only child, Cornelia (1900–1976), was born in Biltmore House on August 22, 1900. In typical Vanderbilt fashion, Cornelia's arrival attracted national attention. *The New York Times* published an article stating that enthusiasm over Cornelia's appearance was tempered by the fact that "the Northern papers were enterprising enough to publish elaborate and detailed accounts of the birth of the child several weeks ago, and therefore its actual advent into this world does not excite as much interest as would otherwise have been the case." At home, *The Asheville Daily Citizen* wrote, "The little stranger is a Buncombe [County] baby—pretty as babies go—but with the Buncombe birthright of . . . mountain health."

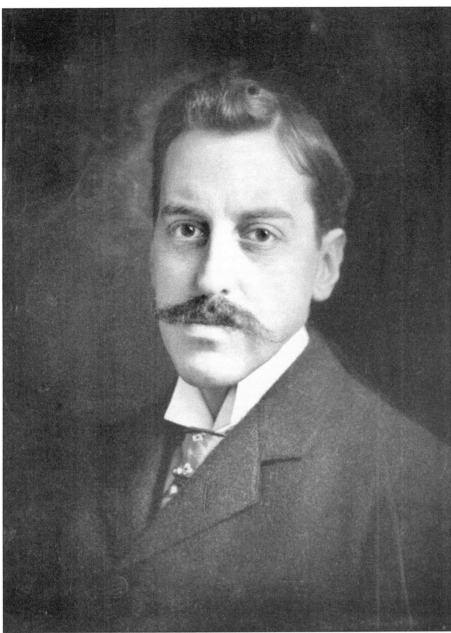

GEORGE W. VANDERBILT, 1914. On March 6, 1914, George Vanderbilt died unexpectedly at his residence in Washington, D.C. At the time of his death, Vanderbilt was recuperating from a routine appendectomy when, according to his attending physician, a blood clot traveled to his heart, causing sudden death. Mrs. Vanderbilt and Cornelia were at his side. Rev. Rodney Swope, rector of All Souls' Parish in Biltmore Village, traveled to Washington, D.C., to perform the funeral service at the Protestant Episcopal Cathedral of Saints Peter and Paul. Following the service, Edith and Cornelia Vanderbilt and other close friends and family members then accompanied Mr. Vanderbilt's body to New York. He was interred in the Vanderbilt Family Mausoleum in Staten Island, New York, where his father, grandfather, and oldest brother Cornelius Vanderbilt II had also been placed after their deaths.

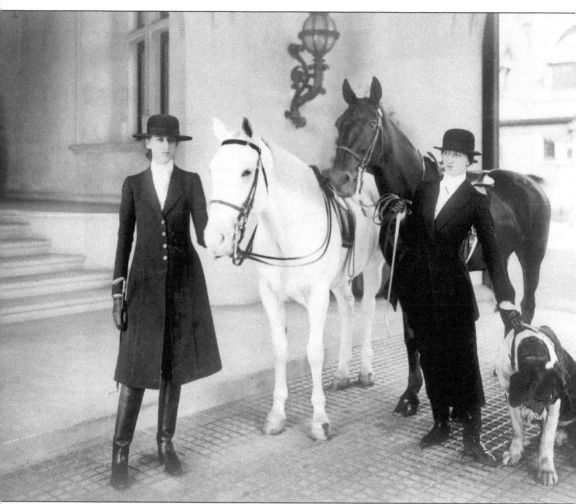

EDITH AND CORNELIA VANDERBILT, C. 1916. According to the terms of George Vanderbilt's will, Edith Vanderbilt inherited most of George Vanderbilt's property, including homes in Bar Harbor, Maine, and in Washington, D.C., and over 112,000 acres of land in North Carolina. George Vanderbilt also left her a life estate trust fund valued at $1 million and an additional $250,000 in cash. Their daughter, Cornelia, received the $5 million trust fund that her father had inherited from his father, as well as Biltmore House and the remaining land. This property was to be held in trust by George Vanderbilt's executors until Cornelia reached the age of 25. Edith and Cornelia continued to make Biltmore Estate their main residence after George's death, though entertaining and recreational activities diminished for several years. In this portrait, Edith and Cornelia are shown in riding attire under the Porte Cochère at Biltmore House.

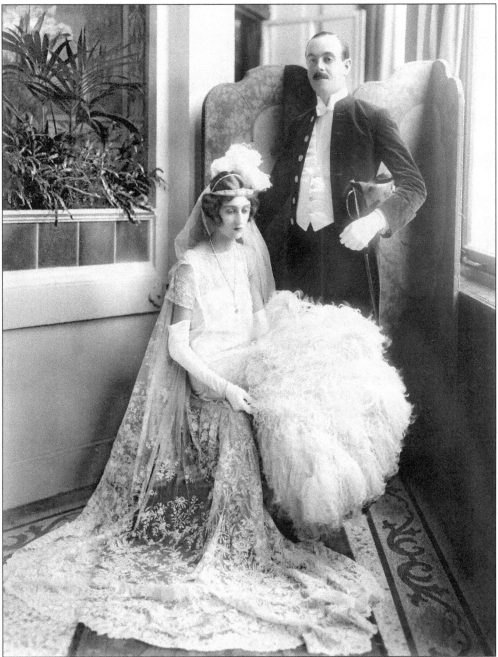

THE HONORABLE AND MRS. JOHN FRANCIS AMHERST CECIL, 1924. Edith Vanderbilt maintained the residence she and her husband had shared in Washington, D.C., after her husband's death. This allowed her to remain close to her teenaged daughter, Cornelia, who attended a private boarding school in the nation's capitol during her high school years. Cornelia Vanderbilt met her future husband, John Francis Amherst Cecil (1890–1954) in Washington, where he served at the British Embassy. After their wedding in April 1924, Mr. and Mrs. Cecil took an extended honeymoon in Europe. This portrait, shot by noted London photographer Langfier, was most likely taken in London during their honeymoon.

CORNELIA VANDERBILT CECIL AND SON GEORGE, C. 1928. John and Cornelia Cecil's eldest son, George Henry Vanderbilt Cecil, was born on February 27, 1925.

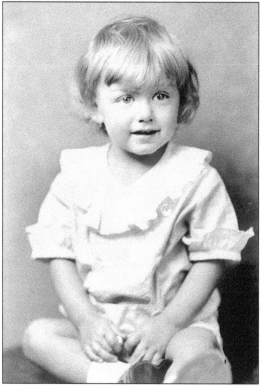

WILLIAM AMHERST VANDERBILT CECIL, 1930. William Cecil, second son of John and Cornelia Cecil and grandson of George Vanderbilt, arrived on August 25, 1928. Like his elder brother, William was born at Biltmore and spent his early childhood years on the estate.

Two

THE CREATION
OF BILTMORE HOUSE
AND GARDENS

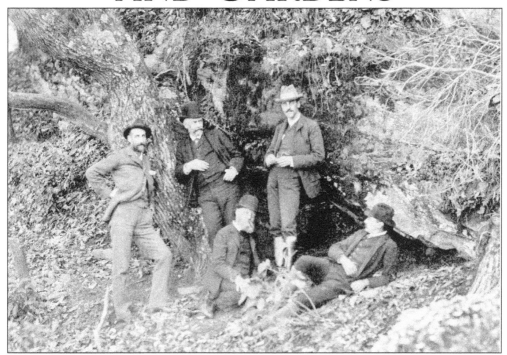

PRINCIPAL FIGURES IN THE CREATION OF BILTMORE ESTATE, 1892. From left to right are purchasing agent and agricultural consultant Edward Burnett, architect Richard Morris Hunt, landscape architect Frederick Law Olmsted, George Washington Vanderbilt, and architect Richard Howland Hunt, son of Richard Morris Hunt. Both the elder Hunt and Olmsted worked with Vanderbilt before Biltmore: Hunt and Olmsted on the design of the Vanderbilt Family Mausoleum in Staten Island, New York, and Olmsted on the landscape of Vanderbilt's Bar Harbor home.

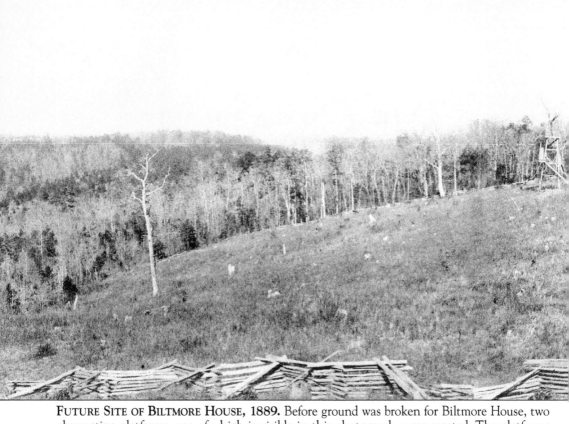

FUTURE SITE OF BILTMORE HOUSE, 1889. Before ground was broken for Biltmore House, two observation platforms, one of which is visible in this photograph, were erected. The platforms allowed Olmsted to confirm that the vistas Vanderbilt admired would be visible from within Biltmore House. Charles McNamee, acting on Mr. Vanderbilt's behalf, purchased several separate

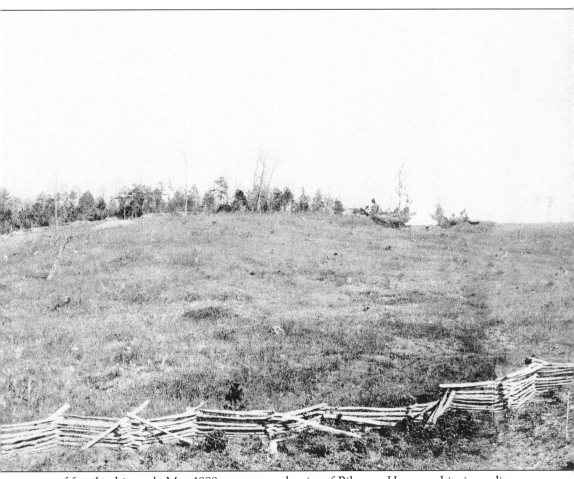

tracts of farmland in early May 1888 to serve as the site of Biltmore House and its immediate grounds. Because the Vanderbilt name was easily recognized and symbolized unlimited wealth, George Vanderbilt had all initial purchases recorded in Charles McNamee's name in an effort to prevent land prices from soaring.

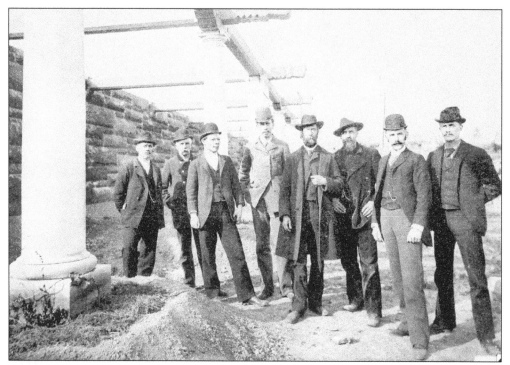

BILTMORE HOUSE CONTRACTORS AND CONSTRUCTION SUPERVISORS, 1892. From left to right are J.L. Howard, engineer; George R. Olney, engineer; A.E. Schneeweiss, draftsman; E.C. Clark, probably an engineer; W.A. Thompson, chief engineer; F.M. Weeks, chief contractor; R.S. Smith, supervising architect; and J. Berrall, occupation unknown.

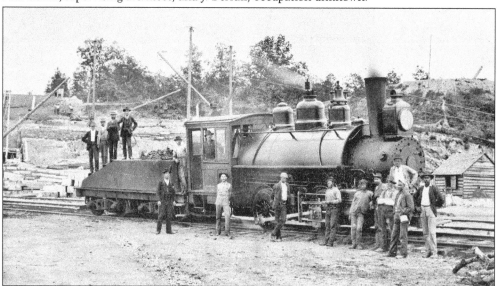

WORKERS AND A BALDWIN STEAM ENGINE ON THE ESPLANADE, 1892. The contract between Richard Morris Hunt and general contractor D.C. Weeks & Son stipulated that the massive quantities of Indiana limestone required in the construction of Biltmore House be shipped by rail directly to the house site. A railroad track was laid from the depot three miles away in nearby Best (later known as Biltmore Village) to the building site, allowing for efficient delivery.

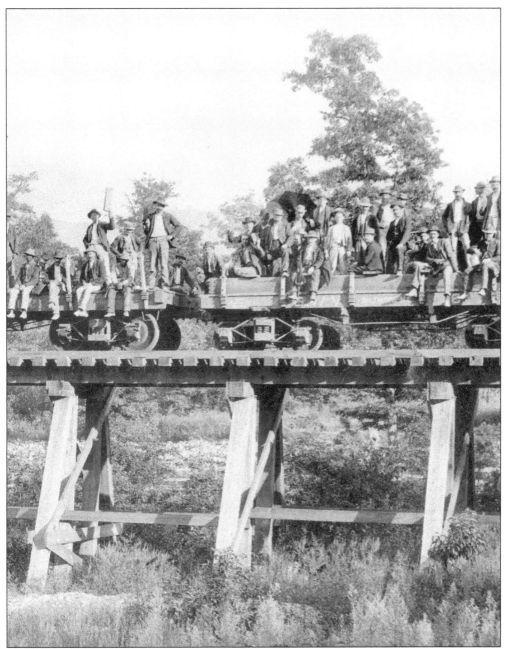

WORKERS BEING TRANSPORTED TO THE BUILDING SITE, C. 1892. Just as materials needed to be transported to the construction site, so too did workers. This photograph was taken at one of several trestles built to cross ravines near the house site. Hundreds of landscape workers, road builders, and construction workers, many of whom were local unskilled day laborers, rode on flatbed railroad cars to the job site, arriving at around 7:30 a.m. and returning to the village about 10 hours later. By the 1890s, organized labor unions were spreading their influence across the United States. On various occasions, Biltmore's construction workers demanded shorter hours, more pay, improved transportation, paid school tuition for their children, and paid medical expenses for on-the-job injuries. Most disputes were settled amicably.

23

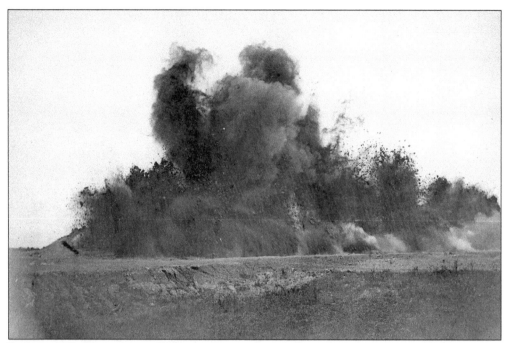

BLAST OF EARTH AT THE ESPLANADE, AUGUST 1891. Vanderbilt chose the location for Biltmore House based on surrounding mountain vistas. The house site, however, was far from level, so three separate hills had to be removed to create a flat, compacted building surface. Massive quantities of blasting powder and dynamite were purchased from several dealers to remove an estimated 106,000 to 181,000 cubic yards of soil.

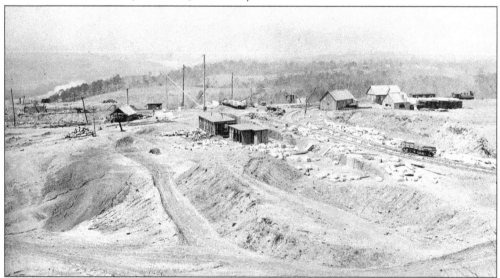

EARLY VIEW OF THE ESPLANADE, 1891. In March 1891, supervising architect Richard Sharp Smith asked estate superintendent Charles McNamee for permission to locate a number of temporary sheds on the Esplanade. Over time, sheds went up for architects, engineers, brick masons, stonemasons, landscapers, carpenters, cabinetmakers, blacksmiths, roofers, plasterers, and plumbers. Stables and storage sheds were also built. Night watchmen protected the construction site from theft and fire.

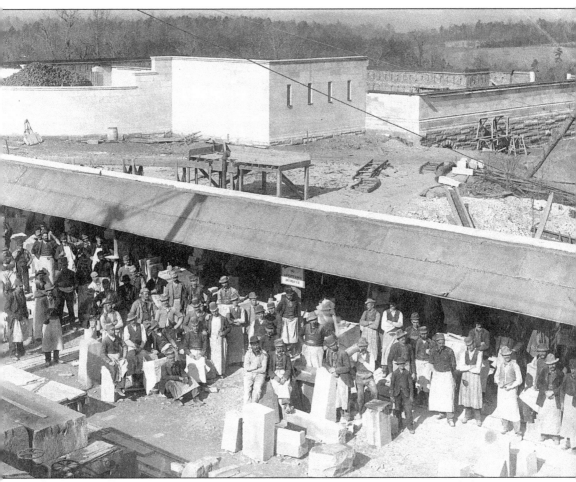

STONEMASONS' SHED, DECEMBER 1892. The contract for stonemasonry was awarded to James Sinclair & Company of New York. Stonemasonry was a highly skilled trade, with stonemasons earning more than other construction workers—$3.50 per day. By comparison, carpenters made about $2.50 per day, while unskilled laborers might earn $1 per day. Stonemasons and other skilled tradesmen like cabinetmakers and electricians were not usually available for hire locally and were therefore recruited from remote locations like New York City and Cincinnati. Many of them were recent immigrants from Europe. Ensuring that an adequate supply of limestone and other materials was on hand to meet daily needs was a constant concern. Richard Morris Hunt required supervising architect Richard Sharp Smith to report weekly on the quantity of limestone delivered to the Esplanade to ensure that enough blocks were available. Twenty-five separate memoranda from Smith documented that 287 rail cars transported 9,973,638 pounds of limestone to the site during construction.

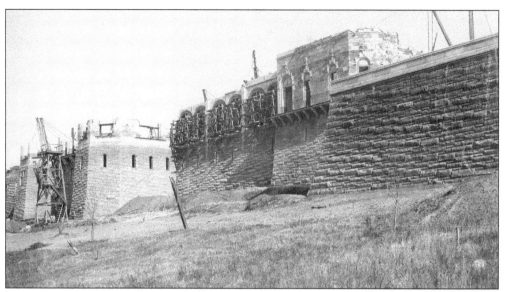

WEST ELEVATION, DECEMBER 1892. This photograph shows the rough-hewn stone exterior of the foundation and basement levels. Richard Morris Hunt, upon seeing this and other photographs of Biltmore House taken at the end of 1892, wrote to Charles McNamee, estate superintendent, "It's trying to look like something!" (Richard Morris Hunt to Charles McNamee, December 7, 1892; letter in the Biltmore Estate Archives.)

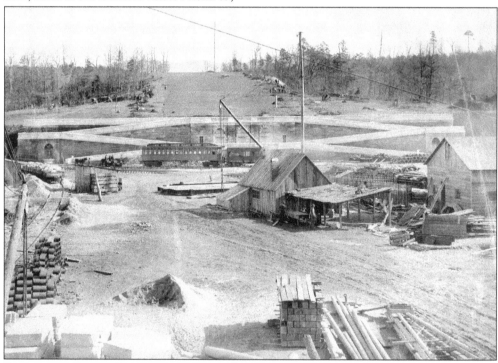

ESPLANADE, RAMPE DOUCE, AND VISTA, FEBRUARY 4, 1892. Landscaping efforts were well underway by the time this photograph was taken in the winter of 1892. Structural work on the Rampe Douce (meaning "pleasant incline") was finished, and grass had been planted on the Vista, where workers were in the midst of tree planting.

26

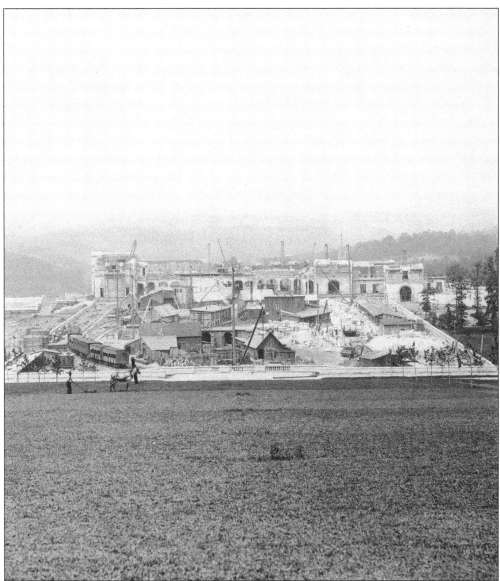

EAST ELEVATION FROM THE VISTA, JULY 26, 1893. By the summer of 1893, almost every inch of the Esplanade was covered by sheds and building materials. The first floor exterior of Biltmore House was complete, and work was progressing on the second floor. The passenger car on the railroad tracks was for the stonemasons, the most elite group of construction workers. They demanded and received covered transportation to and from the construction site so they would be sheltered from bad weather. In the foreground, a landscape worker cuts the grass with a mule-drawn mower. During the construction period, architect Richard Sharp Smith managed construction activities at the job site while Richard Morris Hunt, lead architect, oversaw the design process from his New York City office. Hunt visited the site several times between 1888 and 1895 to check on progress. He died in August 1895, four months before the scheduled completion of Biltmore House.

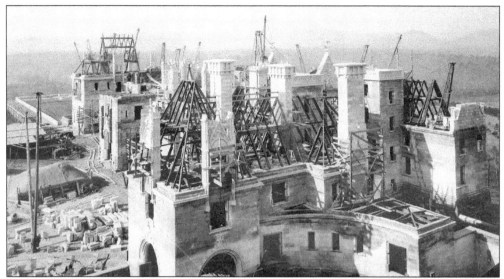

BILTMORE HOUSE FROM THE STABLE COMPLEX, MARCH 10, 1894. Biltmore House was constructed of brick and steel with a limestone veneer. Carnegie Mills supplied iron roof trusses to Pittsburg Bridge Company, which built the roof. Wherever possible, fireproof building materials were used in Biltmore's construction, including iron, steel, brick, ceramic tile, stone, and slate, with wood used only for interior features like floors, paneling, doors, and mantels.

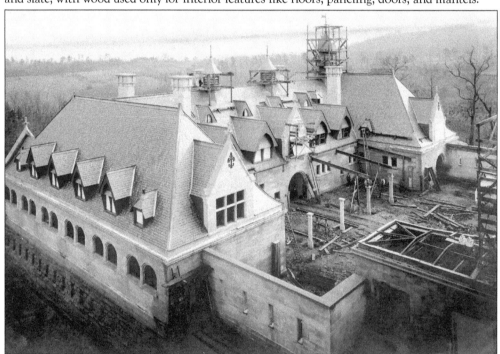

THE STABLE COMPLEX, MARCH 21, 1894. The first floor of the Stable complex consisted of two parallel wings housing the carriage house (on the west end, with arched windows) and the Stable (opposite). A harness room, blanket room, repair room, saddle room, and livery were located in the central part of the Stable on the main floor, while the floors above contained living quarters for male servants.

28

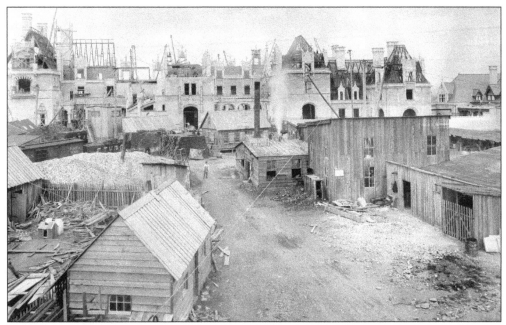

EAST ELEVATION, MAY 8, 1894. This photograph was taken about a year and a half before the completion date of Christmas 1895 imposed by Vanderbilt. Visible in the center is the blacksmith shop, with its tall smokestack. Directly behind the blacksmith shop is a construction office, while to its right is the masonry workshop of James Sinclair & Company. Derricks for lifting heavy materials were scattered across the job site.

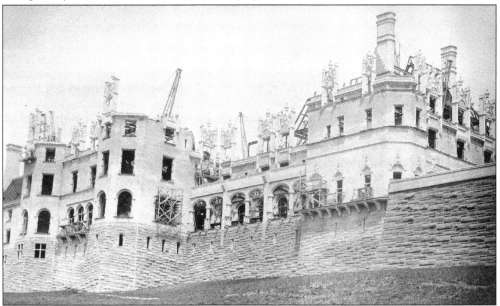

WEST ELEVATION, MAY 8, 1894. Biltmore House measures 375 feet in length, not including the Stable and South Terrace, and 192 feet at its widest point. In order to support the massive weight of the house, the foundation is approximately 29 feet deep and 14 feet thick at its base. Behind the narrow windows on the lower level is the kitchen complex, including the pantries, main kitchen, rotisserie kitchen, pastry kitchen, and living quarters for kitchen staff.

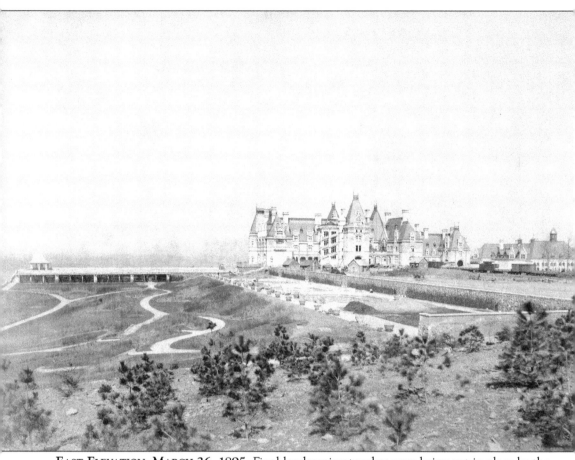

EAST ELEVATION, MARCH 26, 1895. Final landscaping touches were being put in place by the time this photograph was taken in the spring of 1895, with only eight months to go before the completion deadline. Though most work sheds on the Esplanade had been removed, including those of the stonemason contractor James Sinclair & Company, a few, such as the office of supervising architect Richard Sharp Smith, remained. By 1895, the majority of workers still on site were carpenters and cabinetmakers involved in finish work inside Biltmore House. By late October 1895, in the rush to complete Biltmore House by Christmas, when Vanderbilt's family was scheduled to visit, Richard Sharp Smith asked for 16 additional cabinetmakers. In December, he asked for 10 more. Though the bulk of the carpentry crew ceased work in Biltmore House in mid-July 1896, finish work continued in the Library and a few other locations well into 1897.

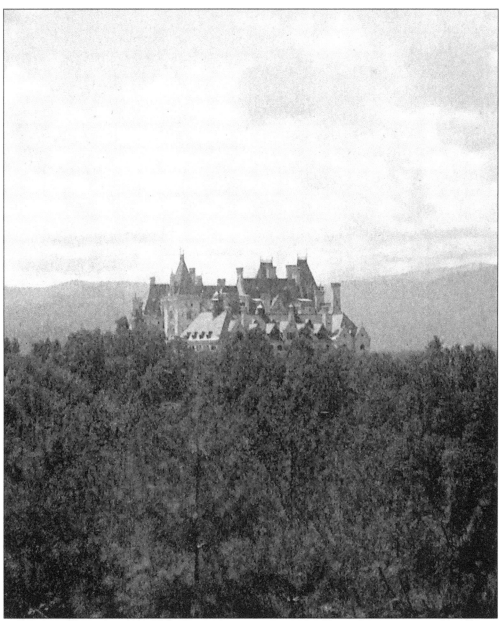

NORTH ELEVATION, C. 1898. This is a rare view of Biltmore House from the north. In devising the approach to the house, Olmsted calculated the emotional impact of a deliberately controlled visual experience. To create a sense of drama and heightened anticipation, he intentionally designed the Approach Road's landscape to conceal the house and the vistas of the Blue Ridge Mountains on the three-mile journey from the estate entrance to the house site. When this photograph was taken, the landscape had not yet matured enough to screen Biltmore House completely from view. The Stable and servants' entrance were placed on the north end of Biltmore House. Employees accessed the Stable and servants' entrance via a road that wound its way to the back of Biltmore House. Olmsted placed the Service Road far from the three-mile Approach Road to ensure that Vanderbilt and his guests would not cross paths with workers and delivery vehicles.

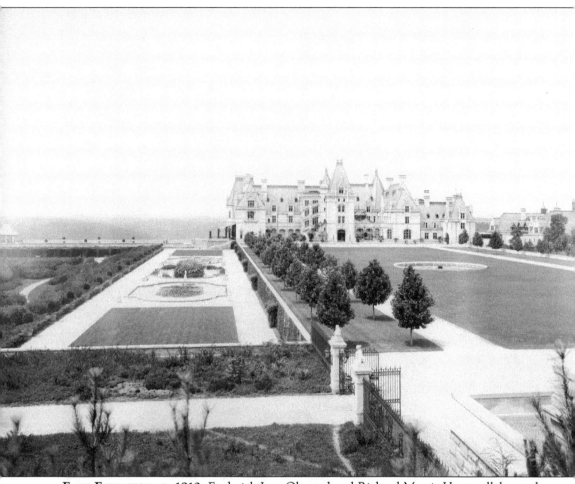

EAST ELEVATION, C. 1910. Frederick Law Olmsted and Richard Morris Hunt collaborated on the design of the Home Grounds (the formally landscaped areas immediately around Biltmore House), with Hunt suggesting the plan for the double allée of trees along the Esplanade and the inclusion of the Rampe Douce and Olmsted designing the Garden Terrace (often called the Italian Garden) and Ramble (or Shrub Garden). Together, they designed the South Terrace. The formal Esplanade and Garden Terrace stand in sharp contrast to the naturalistic woodland landscape of the Approach Road in the previous photograph. This is how Biltmore House and the immediate landscaped gardens surrounding it would have appeared to George Vanderbilt during the last years of his life.

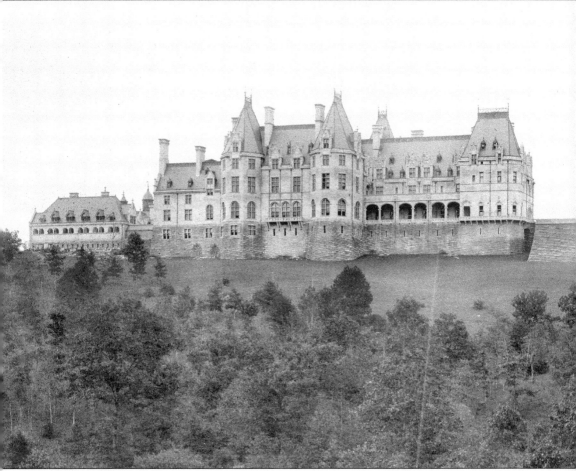

WEST ELEVATION, C. 1910. The complexity of Biltmore's design, with its irregular roofline and multitudinous windows, terraces, balconies, chimneys, towers, and spires, is reminiscent of many chateaux in France, including Blois, Chambord, and Chenonceaux. Richard Morris Hunt, one of the first Americans to graduate from L'Ecole de Beaux-Arts, a renowned Parisian institute of art and architecture in the classical tradition, suggested that Vanderbilt's home should be of a grand design and scale to match that of the surrounding mountains. Though Hunt's initial sketches explored designs in a variety of styles, including Colonial revival, English Tudor, and Italian revival, he ultimately convinced Vanderbilt that the classical French renaissance style was best.

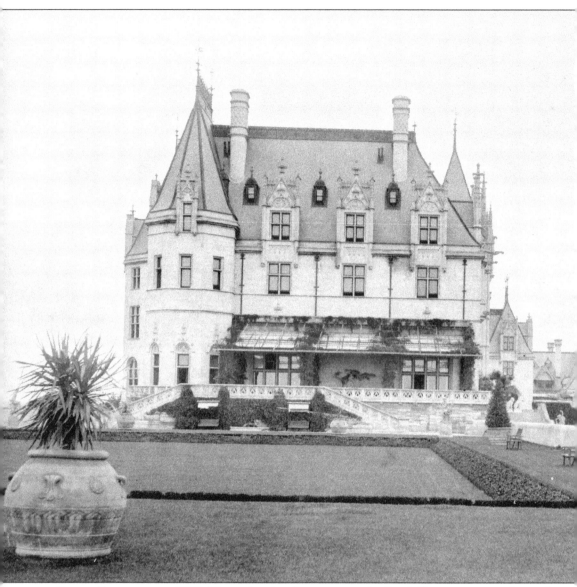

SOUTH ELEVATION, C. 1905. The sunken bowling green on the South Terrace was one of several recreational areas built into the formal grounds. Others included tennis courts and lawns for croquet. Olmsted designed the South Terrace to serve three purposes: to capture the dramatic western views, to provide a place for leisurely strolling and recreation, and to serve as a windbreak to the garden paths that wound their way from the terrace to the Conservatory below. George Vanderbilt played a role in the design as well, personally selecting French terra cotta garden statuary and Italian terra cotta oil jars and planters to ornament the South Terrace.

GARDENER'S COTTAGE AND WALLED GARDEN, FEBRUARY 25, 1893. One of the first buildings completed on Biltmore Estate was the Gardener's Cottage. The first resident of the Gardener's Cottage was Robert Bottomly, head gardener, who moved into the cottage around the same time that this photograph was taken. W.A. Wright originally owned the home in the foreground; Vanderbilt purchased it in June 1888. The date of its removal is unknown.

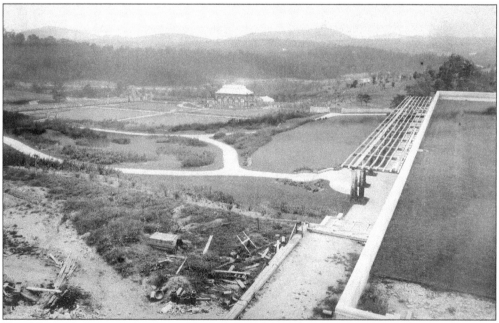

THE HOME GROUNDS, C. 1894. Olmsted shared his ideas for the gardens below the South Terrace with Hunt in a letter dated March 2, 1889: "[A] place out-of-doors is wanted which attractive at all times in a different way from the terrace, will be available for a ramble even during a northwester and in the depth of the winter. This would be a glen-like place with narrow winding paths between steepish slopes with evergreen shrubbery." (Letter in the Biltmore Estate Archives.)

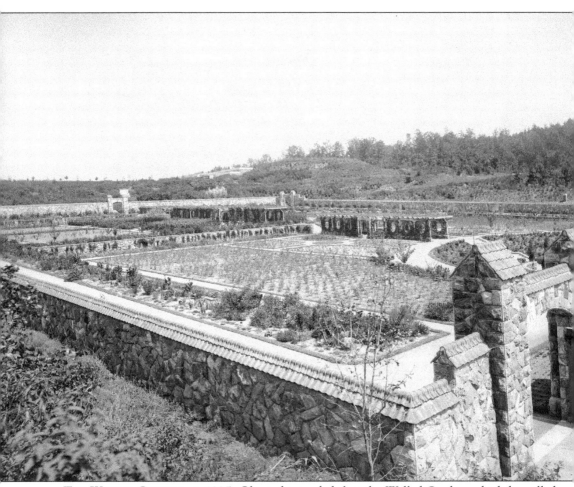

THE WALLED GARDEN, C. 1895. Olmsted intended that the Walled Garden, which he called "the vegetable and flower garden," be functional, supplying Biltmore House with "fine" fruits and vegetables and cut flowers in the European country house manner. George Vanderbilt, however, decided that because he had commercial vegetable gardens and orchards elsewhere on the estate, he wanted the Walled Garden to be purely ornamental. In this early view, hundreds of roses have been planted in the pattern beds in the foreground, bordered by a variety of perennials. Espaliered dwarf fruit trees lined the interior walls. The vine-clad arbor split the Walled Garden in half, lending a classic sense of symmetry to the design. The Rampe Douce is visible in the distance.

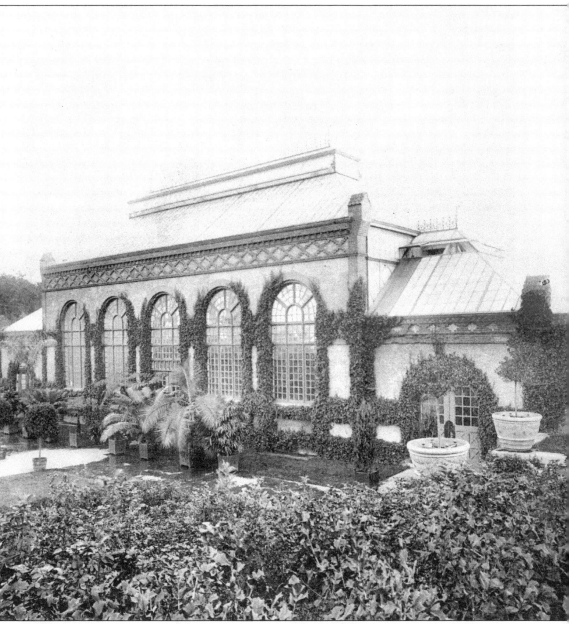

THE CONSERVATORY, C. 1910. Richard Morris Hunt designed the Conservatory while Lord & Burnham, America's foremost builder of greenhouses, fabricated the steel frame and glass roofs of the structure. With approximately 7,500 square feet of heated growing space under glass, the Conservatory not only provided fresh plants and flowers year-round for Biltmore House, but also gave the Vanderbilts and their guests a lush, tropical retreat during wintertime, when the gardens were dormant. The complex included a palm house, an orchid room, a rose room, propagation and production areas, and potting rooms. It was heated in cool weather by a coal-fired boiler located in the basement and a forced hot-water system. In the summer, the temperature was regulated by a system of manually operated roof and side vents.

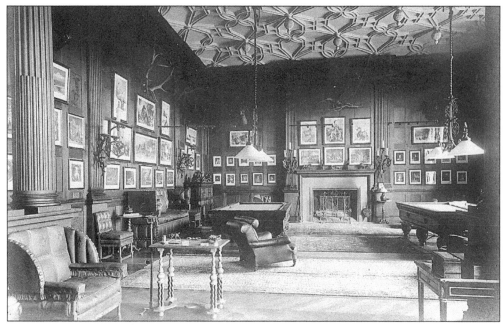

THE BILLIARD ROOM, C. 1910. In 1889, Mr. Vanderbilt and Mr. Hunt traveled to England and France to gain inspiration for the design of Biltmore House and to purchase furnishings. The billiard room has a distinctly English accent. The sofas and chairs, for example, are accurate 19th-century reproductions of 16th-century furniture from the English country house Knole, while the custom-made billiard tables by the Brunswick-Balke-Collender Company are in the English renaissance style. (Photograph donated by Mrs. William Todd Ashby.)

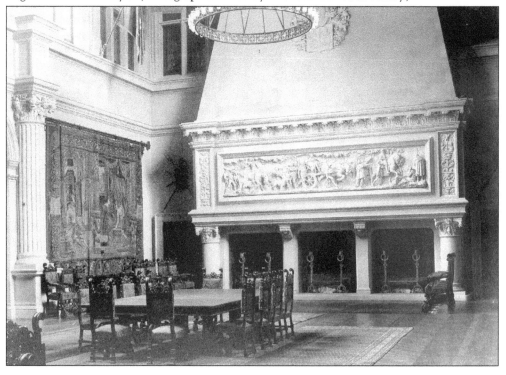

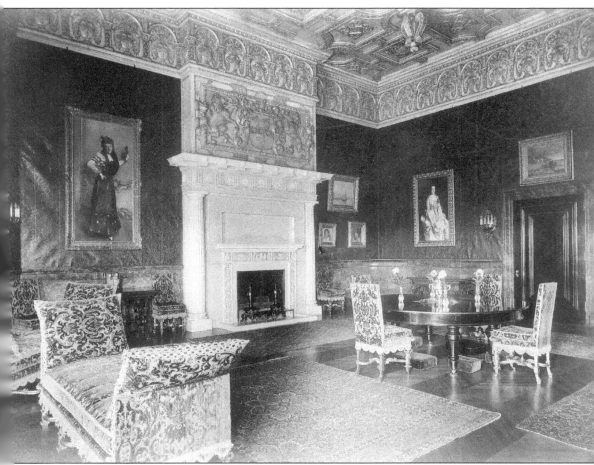

THE BREAKFAST ROOM, C. 1910. Though smaller than the Banquet Hall and used for the less formal meals of breakfast and lunch, the Breakfast Room was certainly no less elegant. Its décor included an ornate multi-hued plaster ceiling, embossed leather and polished marble walls, fine French silk fabrics, important paintings, and an antique English mantel. According to the 1904 menu book maintained by the chef, luncheon was normally served at 1:30. The typical lunch began with fish or a light soup, followed by an egg course. The third course consisted of meat, poultry, or game, accompanied by two or three side dishes of vegetables and rice, macaroni, or potatoes. Next came a salad made of cold vegetables with meat followed by a light dessert. Dinner was generally more elaborate, with a larger number of selections and at least seven courses. (Photograph donated by Mrs. William Todd Ashby.)

opposite, below: **THE BANQUET HALL, C. 1910.** In 1895, George Vanderbilt invited family and friends to Biltmore to celebrate the holidays. An article in *The Asheville Daily Citizen* dated January 1, 1896, captured the spirit of New Year's Eve: "The festivities began with dinner in the Banquet Hall at 8 o'clock. The hall was magnificent in its elaborate appointments of statuary, tapestries and oaken furniture. . . . Three huge log fires glowed in the western end of the room and at the opposite wall, in the organ gallery, the Imperial Trio . . . played their finest selections during the feasting." (Photograph donated by Mrs. William Todd Ashby.)

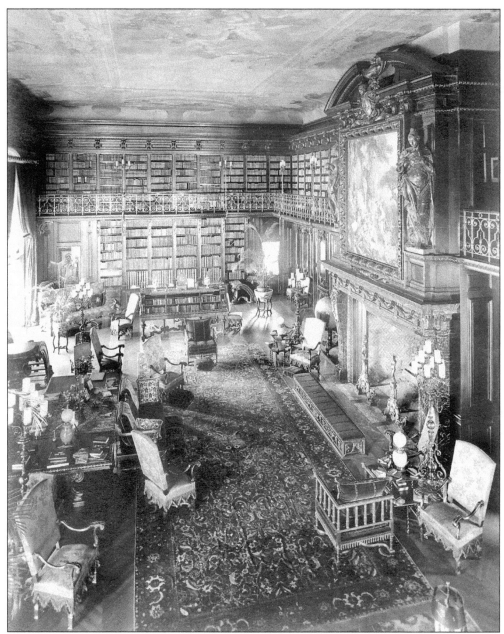

THE LIBRARY, C. 1910. Perhaps no room better represents George Vanderbilt and his interests than the Library, designed to feature his renowned book collection. Texas Bates McKee, a frequent visitor in the early 1900s, wrote fondly of the Library in her unpublished memoirs: "The George Vanderbilts were in residence during our first winter [in Asheville] and perhaps twice a week we would dine with them and George would read aloud as we gathered by the fire in the fabulous library." Edith Vanderbilt's sister Pauline Dresser Merrill, in a letter to a friend written at Biltmore in 1905, captured the feelings of many when she wrote: "Books everywhere . . . on the right and on the left, every sort of book, first editions and current literature, books, books, books and a comfortable chair in which to read them." (Mrs. Grenville Merrill to Mrs. T.S. Viele, March 1905.)

Three

TRANSFORMING
THE LAND

THE FRENCH BROAD RIVER AND BOTTOMLAND, 1889. The land that would eventually become Biltmore Estate consisted of a large number of small private farms and home sites when Vanderbilt first visited. He began purchasing these tracts on May 3, 1888, acquiring 597 tracts totaling over 55,000 acres in Buncombe County, with additional purchases in Henderson, Transylvania, and Haywood Counties. By the time of his death, Vanderbilt's holdings encompassed approximately 125,000 acres.

ALEXANDER MILL, C. 1890. The Alexanders were among the Asheville area's early residents. Buncombe County was established in 1792 on land that they and other prominent citizens like the Davidsons, Hawkins, and Pattons settled, near the junction of the Swannanoa and French Broad Rivers. The Alexander Mill and related structures were located on a tributary of the French Broad River southwest of Biltmore House.

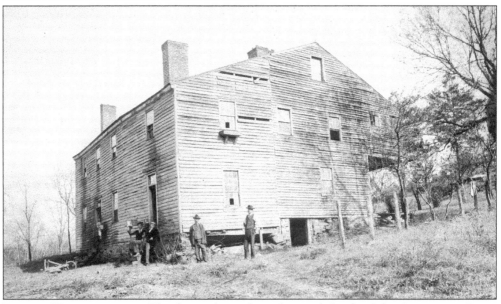

PATTON HOUSE, C. 1890. This home, located on the south bank of the Swannanoa River, originally belonged to Col. John Patton, a prominent early settler. Preston Patton, a descendant, sold the home and 385 acres of fertile farmland to Vanderbilt in 1889. When this photograph was taken, the Patton House may have served as a temporary residence for estate workers. The home was ordered to be razed in October 1895.

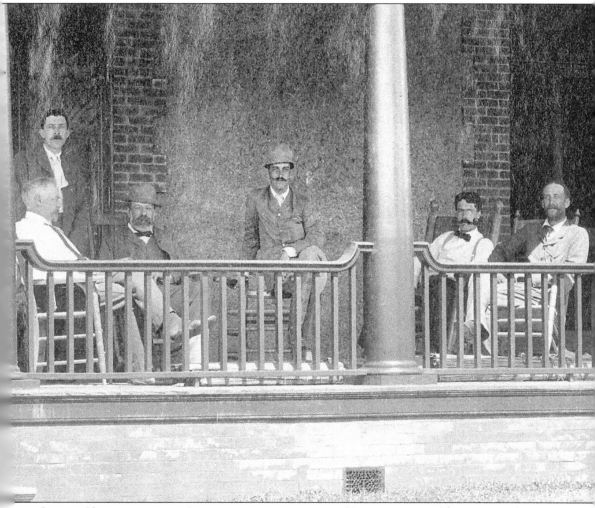

GEORGE VANDERBILT AND GUESTS AT THE ALEXANDER HOUSE, C. 1893. The property that B.J. Alexander sold George Vanderbilt in 1889 included not only a mill and farm buildings but also a comfortable home commonly referred to as the Brick Farm House. After Vanderbilt purchased the Alexander tract, he had the house updated and also installed a resident caretaker to maintain it. Vanderbilt, consulting architects, and others occupied this house when they visited the estate during the construction period. Pictured here are architect Richard Morris Hunt (seated on the far left), George Vanderbilt (center), and purchasing agent Edward Burnett (far right). The other men are unidentified. The Alexander House remained standing into the early 1900s. The exact date of its removal is unknown.

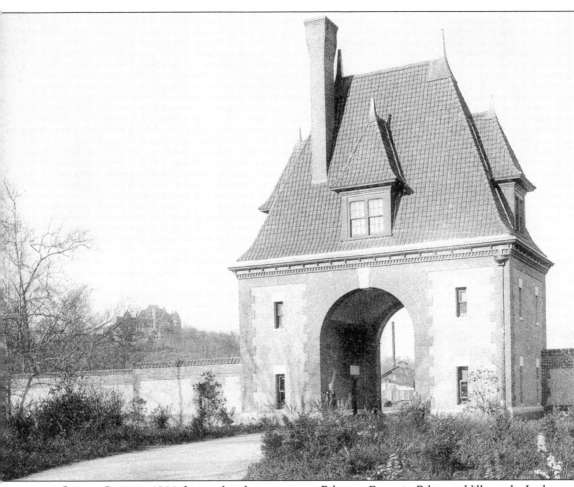

LODGE GATE, C. 1900. Located at the entrance to Biltmore Estate in Biltmore Village, the Lodge Gate provided round-the-clock security by means of a resident gatekeeper. Other entrances to the estate also had gatehouses and gatekeepers, though the Lodge Gate was considered the main entrance. In this photograph, the Biltmore Brick and Tile Works, which supplied materials to the estate during construction, is visible through the archway. In the distance is the original Kenilworth Inn, a luxury hotel built in the 1890s that burned to the ground in 1909. It was rebuilt in 1918. George Vanderbilt was a principal investor in the original Kenilworth Inn, which ran into financial problems early on that were attributed to poor management. Vanderbilt was frequently called upon to supply money to save the inn from bankruptcy. (Photograph from *Biltmore Photogravures*, H.T. Rogers, 1900.)

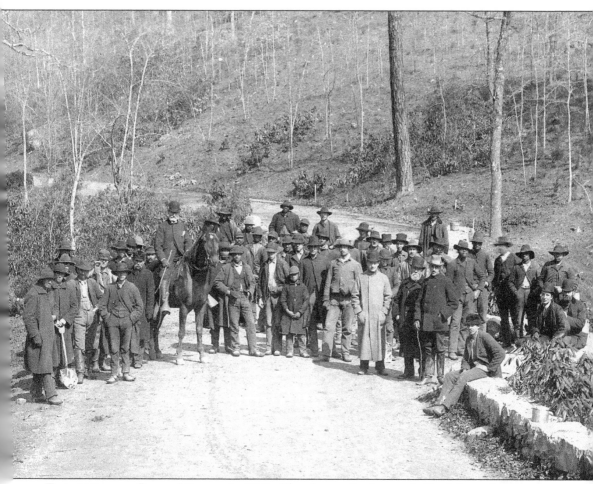

THE APPROACH ROAD, MARCH 4, 1891. The three-mile Approach Road from the estate entrance in Biltmore Village to Biltmore House is considered one of Frederick Law Olmsted's design masterpieces. Olmsted hired engineer James Gall Jr., who had worked with him as assistant drainage engineer on the creation of Central Park in New York City, to manage road construction, grading, and other landscaping activities. Gall's workforce was the largest on the estate during the construction period. Gall is most likely the gentleman on horseback, while George Vanderbilt is standing in the front row on the far right, with Frederick Law Olmsted, the gentleman with the white beard, next to him. Chauncey Beadle, originally hired as Gall's assistant, stands next to Olmsted. Most of the men working in the landscaping department were hired from the local community.

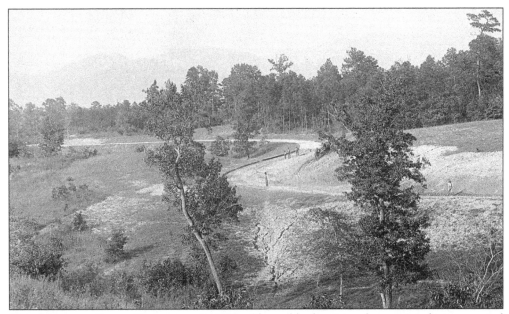

THE APPROACH ROAD, SEPTEMBER 8, 1891. Olmsted had a vision for turning the over-grazed farmland and cutover woodland into a landscape that would mimic the natural beauty of the surrounding mountains. He described his intentions for the Approach Road in a letter to Vanderbilt in July 1889 by saying that it "shall have throughout a natural and comparatively wild and secluded character; its borders rich with varied forms of vegetation." (Letter in the Biltmore Estate Archives.)

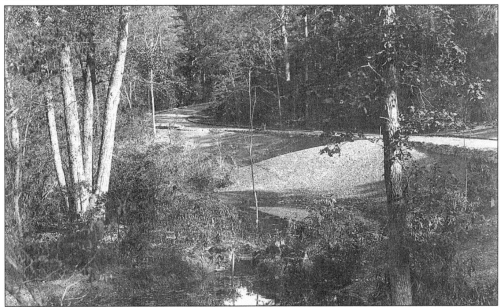

POOL ON THE APPROACH ROAD, SEPTEMBER 8, 1891. Olmsted went on say that the Approach Road should have "springs and streams and pools, steep banks and rocks, all consistent with the sensation of passing through the remote depths of a natural forest." In 1890, before the roadbed was laid out, Olmsted instructed Gall to modify the stream channel of nearby Ram Branch so that these naturalistic effects could be achieved.

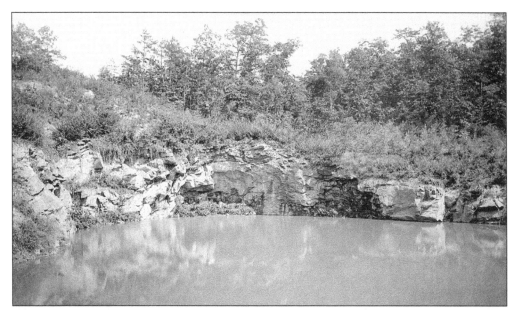

QUARRY ON THE APPROACH ROAD, C. 1895. Much of the granite-like stone (micaceous gneiss) used in the construction of garden walls, bridges, and roads came from a quarry located on estate property. Because the quarry was situated directly along the path of the Approach Road, Olmsted converted it into a landscape feature, diverting nearby Ram Branch to fill the quarry with water to become a pond. The construction of Interstate 40 through the estate in the 1960s forced the removal of the pond.

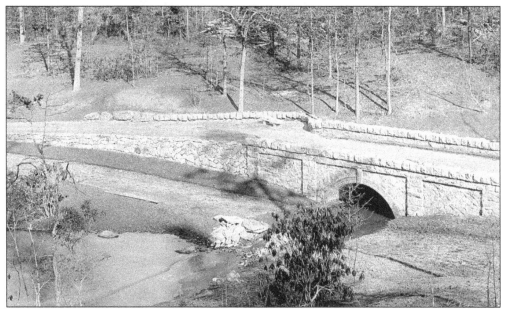

BRIDGE ON THE APPROACH ROAD, 1890. Olmsted intended that the three-mile approach to Biltmore House be a pleasurable experience for those who made the 45-minute journey. In the design of this and other bridges, Olmsted incorporated rustic stone benches so that visitors could relax and take in the charm of the landscape while thirsty horses were watered at the stream beneath the bridge.

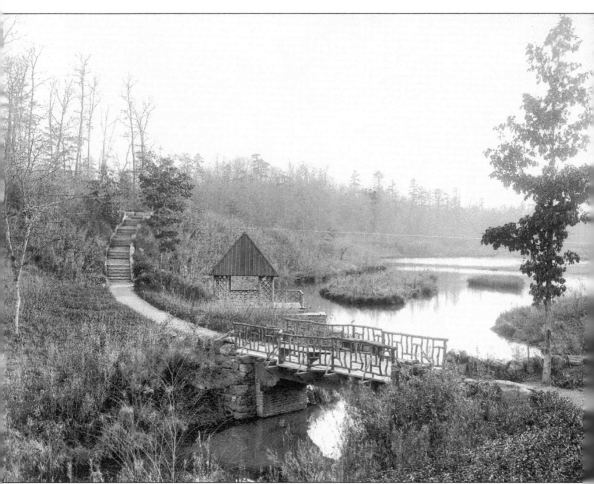

BASS POND, C. 1895. Located at the site of the old Alexander Mill Pond, the lake, later known as the Bass Pond, provided "an effect of intricacy and mystery" below Glen Road, which led from the Esplanade to the river bottom of the French Broad. Olmsted's ingenious design for the Bass Pond included a flume that diverted storm runoff and debris away from the pond into Four-Mile Branch below, so that the pond stayed clean and free of silt buildup. Olmsted described the small islands as "breeding places for shy waterside birds, many of which will only make their nests in the seclusion of thickets apparently inaccessible." Richard Morris Hunt and Frederick Law Olmsted collaborated on the design of the rustic boathouse and footbridge in the Adirondack style. (Letter from Frederick Law Olmsted to George Vanderbilt dated January 29, 1891; in the Biltmore Estate Archives.)

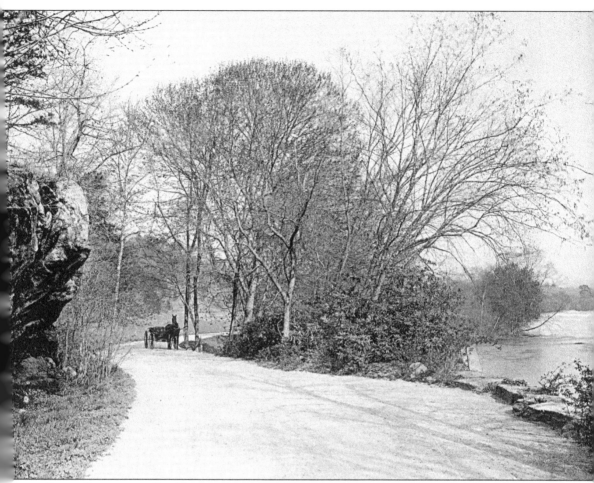

RIVER ROAD NEAR BIG ROCK, C. 1900. The horse and carriage in this view belonged to an unidentified New York photographer hired by H. Taylor Rogers, bookseller and stationer. In 1900, Rogers published *Biltmore Photogravures,* an authorized pictorial guide to Biltmore Estate that included this photograph. In the introduction, Rogers wrote of the grounds, "Under the direction of Frederick Law Olmsted, the veteran landscape architect, 10,000 acres have been converted into a magnificent park, bordered for five miles by the romantic French Broad and Swannanoa Rivers. . . . Every spot in sight of the visitor is cultivated with flowers, shrubs, vines, trees and plants, to grow in time into a unique model of a park." Estate grounds were open to the public on Wednesday and Saturday afternoons. (Photograph from *Biltmore Photogravures,* H.T. Rogers, 1900.)

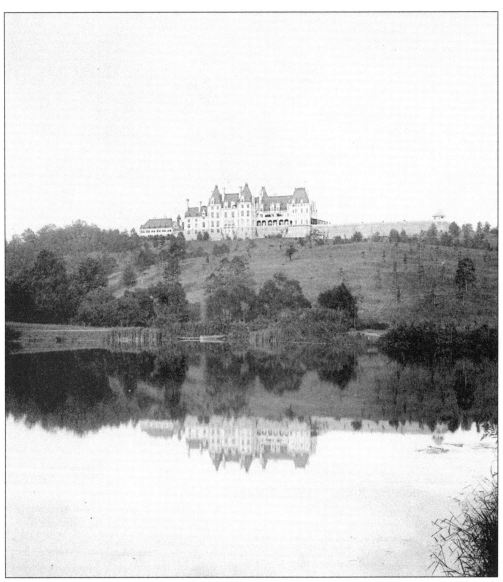

West Elevation of Biltmore House Reflected in the Lagoon, c. 1900. Though Frederick Law Olmsted designed this small lake located between River Road and the French Broad River, it was not completed until after his retirement. In 1895, Olmsted Sr. began having problems with his memory that ultimately led to his confinement in a mental institution in Waverly, Massachusetts, where he died in 1903. Olmsted's sons John C. Olmsted and Frederick Law Olmsted Jr. took over management of their father's business after his retirement. The firm Olmsted Brothers completed the Lagoon and many other elements of Biltmore Estate's landscape. Besides being stocked with large-mouth bass, the Lagoon was also the perfect habitat for wildlife. In 1909, Mrs. Vanderbilt wrote Dr. Carl Schenck from Paris that her muskrat skins, trapped at the Lagoon, were much admired by fashionable society.

LOWER RESERVOIR UNDER CONSTRUCTION, BUSBEE MOUNTAIN, C. 1918. Having an adequate, reliable water source was essential to all operations on Biltmore Estate, both during construction and after. Not far from Biltmore Estate on Busbee Mountain, such a source was found. An upper reservoir was built first c. 1895. To meet increasing demands for water, this lower reservoir was added several years later.

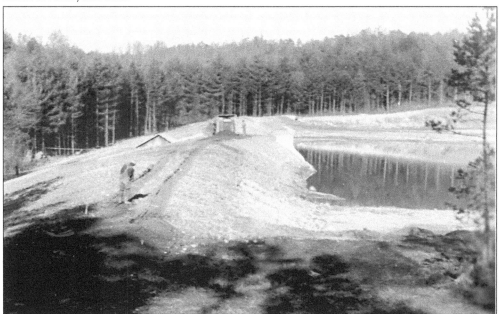

LOWER RESERVOIR, BUSBEE MOUNTAIN, C. 1918. When the reservoir was at full capacity, water flowed by gravity through an intake valve and conduit three miles to a state-of-the-art storage reservoir and filtering station on Lone Pine Mountain, located about one-quarter of a mile east of Biltmore House. From there, it flowed to the house, to nearby fountains, and to the gardens for irrigation purposes.

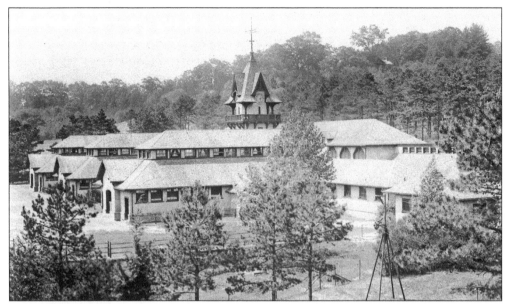

THE DAIRY BARN, MAY 30, 1913. Designed by Richard Howland Hunt in 1900, the Dairy Barn had three parallel wings that accommodated 30 milking cows each, with additional space for bulls and feed. Its technologically advanced features included enameled tile for easy cleaning, cold storage, and ice and electric plants. A heating system controlled temperatures during the winter, while large sash windows allowed for adequate ventilation during the summer. (Photograph donated by Alice Marie Lewis.)

THE CREAMERY, MAY 30, 1913. Raw milk traveled via an overhead tramline from the Dairy to the Creamery, where cream was separated from milk. Milk was then bottled and sold while cream was used to make products like butter and ice cream. Here, a can of milk is visible hanging from the tramline, about to enter a window on the upper floor. Biltmore operated a successful commercial dairy for nearly eight decades. (Photograph donated by Alice Marie Lewis.)

DAIRY WORKERS (UNIDENTIFIED), 1913. Many dairy workers and their families lived on Biltmore Estate. In the early 1900s, dairyman Charles Gaddy ran Pine Top, one of several dairy operations on the estate. In a 1991 oral history interview, his daughter Viola recalled her parents waking her at four in the morning and carrying her to the barn, where she would fall back asleep while her parents milked the Jersey herd they tended.

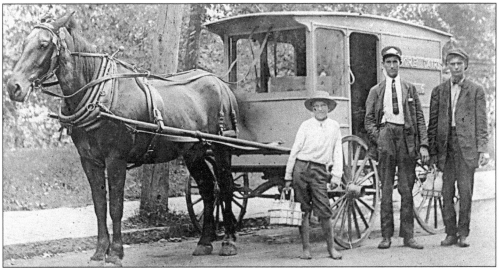

BILTMORE DAIRY DELIVERYMEN, C. 1905. Pictured from left to right are helper Fred Easley, route salesman B.A. Towe, and assistant Bo Gillespie. Route salesmen delivered milk to private residences in the area as well as hotels and restaurants. Horses wore rubber shoes so their footsteps would not awaken sleeping residents during early morning deliveries. The market for Biltmore Dairy products ultimately grew to encompass all of North Carolina and parts of South Carolina. (Photograph donated by Paul Towe.)

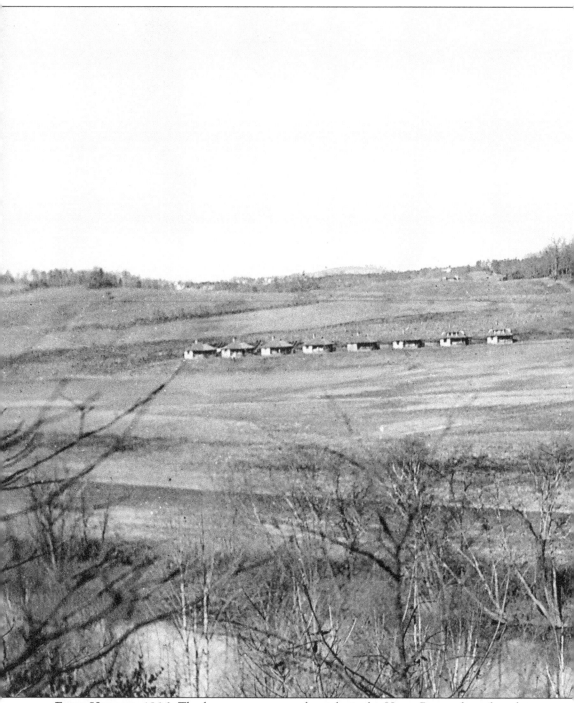

FARM VILLAGE, 1906. The large structure on the right is the Horse Barn, where farm horses and draft horses used to deliver the Dairy's products were stabled. The Horse Barn also included a blacksmith shop, a wagon and equipment repair shop, and a three-story barn for the storage of animal feed and other supplies. The four larger houses on either side of the horse barn are most likely where the estate veterinarian, a farm manager, the Dairy manager, and the

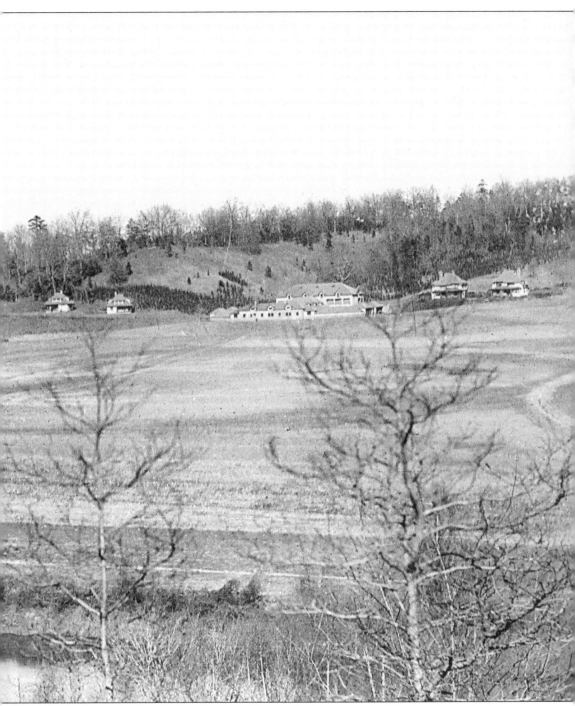

Creamery manager lived with their families. The smaller houses on the "the Line" were for farm and dairy workers. While waiting for the bus to take them to school, children from the Line often congregated in the blacksmith shop, warming their hands at the smithy's forge on cold winter mornings.

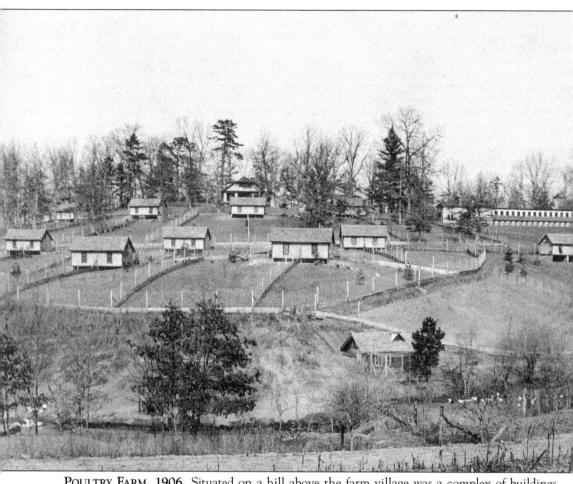

POULTRY FARM, 1906. Situated on a hill above the farm village was a complex of buildings comprising the Poultry Farm. The small buildings dotting the hillside were double hen houses. The larger building on the ridge top to the left was the chicken tender's house. The main building housed an incubator room and a double brooder house connected by a long feeding shed, breeding pens, and an office. Richard Howland Hunt designed all of these buildings, as well as most other farm structures on Biltmore Estate. The first Poultry Farm foreman, J.J. Lenton, bred several varieties of chickens as well as Cornish game hens, "Pekin" ducks, and turkeys. Biltmore poultry frequently won awards at competitions across the United States. *The Asheville Daily Citizen* reported on December 21, 1897, that at the Washington, D.C. Poultry Show, "the most notable of the prizes taken" was awarded to Biltmore for its first-place Black Minorca cocks. (Photograph from *Biltmore Photogravures*, H.T. Rogers, 1900.)

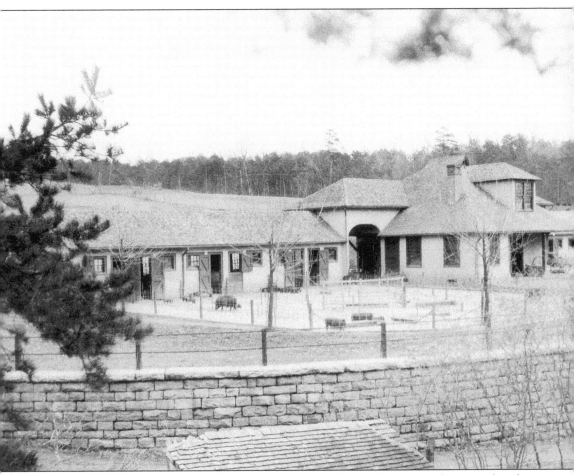

PIG FARM, 1906. Sometimes referred to as "the piggery," this farm, like most other agricultural operations on Biltmore Estate, was a commercial enterprise. According to a letter in the Biltmore Estate Archives, Reuben Gentry, manager of the Pig Farm, traveled to England in 1899 to purchase Berkshire hogs "with a view to establishing a considerable business . . . in the breeding and sale of high-class stock." In 1903, the Pig Farm burned to the ground but was quickly rebuilt exactly as before. Besides pigs and poultry, Southdown sheep and Jersey cattle were also bred for sale throughout the United States, with shipments taking place on an almost daily basis. George Vanderbilt chose to shut down the Pig Farm in 1912 because of disappointing sales. The farm buildings were later torn down. (Letter from Charles McNamee to Frank S. Gannon, general manager of Southern Railway, January 4, 1899.)

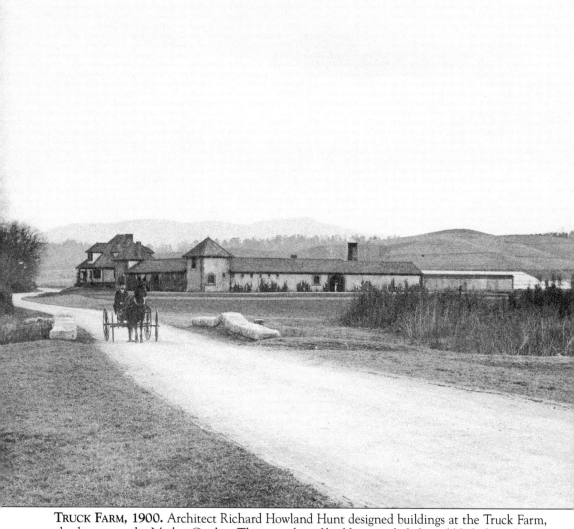

TRUCK FARM, 1900. Architect Richard Howland Hunt designed buildings at the Truck Farm, also known as the Market Garden. This complex of buildings included a pebbledash gardener's cottage, greenhouses, and stables. It was situated close to the banks of the Swannanoa River among fertile fields where a wide variety of fruits and vegetables such as melons, berries, lettuce, potatoes, beans, and cabbage were grown. Glass-roofed greenhouses allowed for year-round production, with lettuce and tomatoes being the primary winter crops. The Market Garden supplied produce for the Vanderbilts, their guests, and servants at Biltmore House, as well as for sale locally in Asheville markets and throughout the South. Not everyone was interested in paying for their produce, however, as Biltmore Estate had recurring problems with locals pilfering watermelons and other produce from the fields. To discourage thieves, harmless "Torpedo Alarms" that sounded an alert when disturbed were placed among the plants. (Photograph from *Biltmore Photogravures*, H.T. Rogers, 1900.)

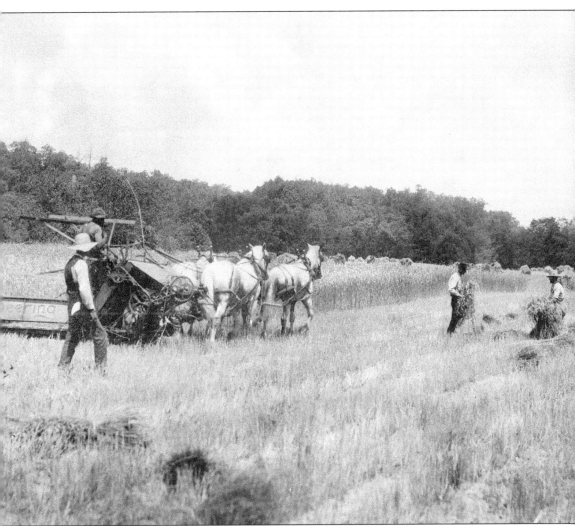

FARM WORKERS HARVESTING GRAIN, C. 1900. Farm workers grew crops of oats, corn, and other grains for animal feed in Biltmore's fertile river bottoms. Here, workers are harvesting oats using a McCormick-Deering grain binder. It produced individual sheaves of grain to be picked up by hand and bound into shocks, comprised of eight to ten sheaves, for curing in the field before threshing. Farm manager George E. Weston, a graduate of an agricultural college and an experienced chemist and farmer, took this photograph. Secretary of Agriculture J. Sterling Morton wrote in 1896 that George Vanderbilt "has employed the best men he can find to take charge of his experiments and pays them salaries that are commensurate with their services. There are Germans and Frenchmen, Italians and Englishmen, as well as Americans employed." (Morton is quoted in "George Vanderbilt and His Southern Work," *The Lyceum,* March–April 1896, p. 20.)

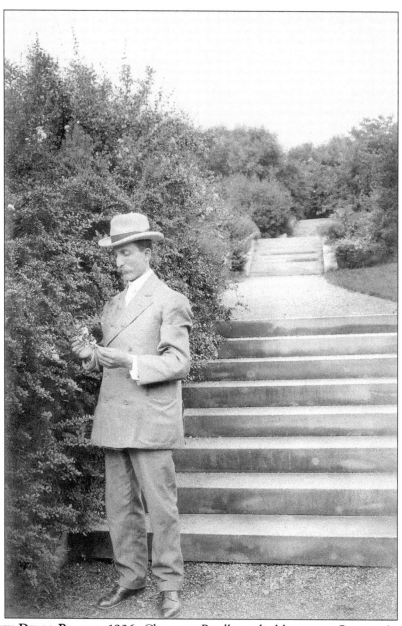

CHAUNCEY DELOS BEADLE, 1906. Chauncey Beadle studied botany at Ontario Agricultural College and Cornell University before being hired by Frederick Law Olmsted in 1890 to assist landscape manager James Gall. Beadle was first put in charge of the Nursery established to provide landscaping plants for Biltmore Estate. In 1898, Beadle expanded the Nursery's operations to include the sale of plants to the public. At the time of a major flood in 1916 that destroyed the Nursery, it was one of the largest commercial nurseries in the United States. Chauncey Beadle also established the Biltmore Herbarium, a scientific collection of over 100,000 individual specimens of Southern plants. The Herbarium was available free of charge to scholars for study. The same flood that destroyed the Nursery wiped out most of the Herbarium. What survived was donated to the Smithsonian Institution. Beadle became superintendent of Biltmore Estate around 1915. He lived and worked on Biltmore Estate until his death in 1950.

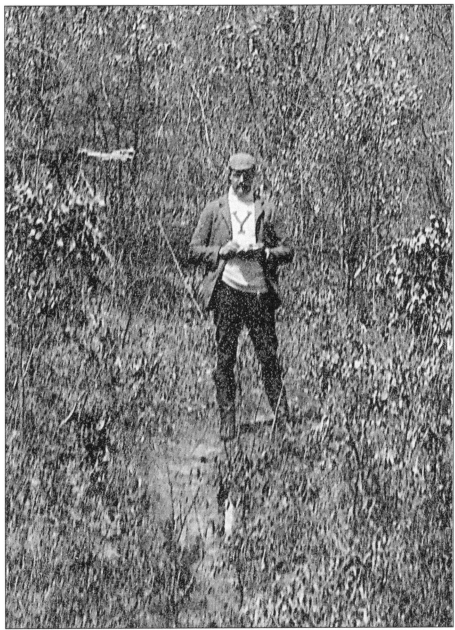

GIFFORD PINCHOT, C. 1893. From the start, Frederick Law Olmsted encouraged George Vanderbilt to implement a sustainable forestry management program at Biltmore. Olmsted suggested that Vanderbilt hire Gifford Pinchot, the first American trained in scientific forestry. After attending Yale University and studying scientific forestry in Europe, Pinchot came to Biltmore Estate in 1892 to implement a practical management plan for the thousands of acres of forested land that Vanderbilt purchased. He consulted regularly over the next several years, putting in place the foundations of a forestry plan. Though his tenure at Biltmore Estate was relatively short, Gifford Pinchot is credited with establishing Biltmore Estate as the "birthplace of forestry" in America. Pinchot went on to become founder and first chief of the United States Forest Service and, many years later, governor of Pennsylvania.

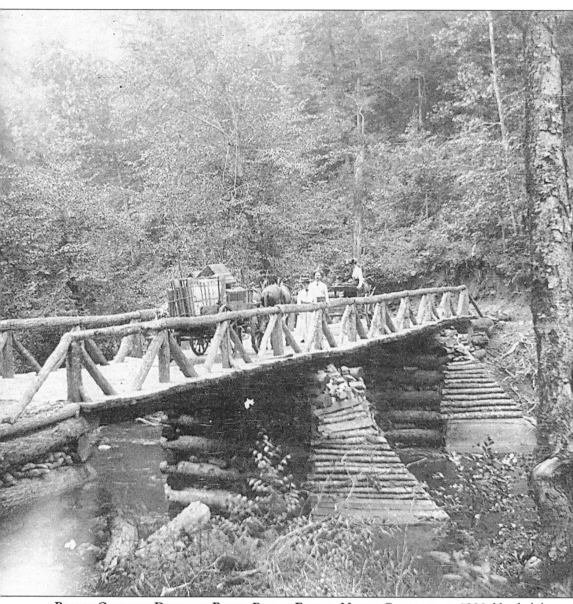

BRIDGE OVER THE DAVIDSON RIVER, PISGAH FOREST, NORTH CAROLINA, C. 1900. Vanderbilt hired Dr. Carl A. Schenck in 1895 to succeed Gifford Pinchot as chief forester at Biltmore Estate. A young German, Schenck was trained in the traditional European methods of forestry. During his 14 years of experimentation at Biltmore, Schenck established himself as one of the pioneers of practical forestry in America. With the purchase of the Pisgah tract, Vanderbilt's land holdings grew to approximately 125,000 acres. Unlike the land surrounding Biltmore House, the majority of the Pisgah tract was remote, rugged, sparsely populated, and covered with virgin timber of the highest quality, including yellow poplar, chestnut, oak, hemlock, black walnut, and beech. In order for a forestry program to be successful, roads and bridges were built to give foresters access to remote areas. This bridge was one of several built by Schenck in the Davidson River area of Henderson County.

Four

A MODEL VILLAGE

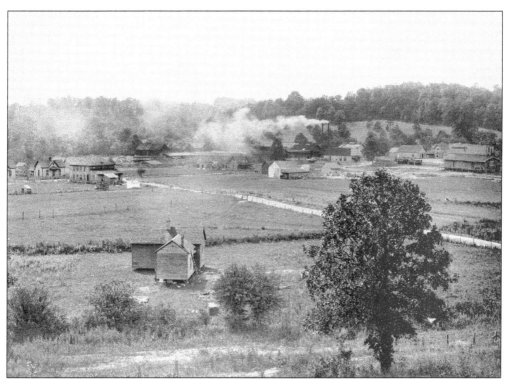

BILTMORE VILLAGE, JULY 7, 1894. Plans for Biltmore Estate included the creation of a "model village" adjacent to the estate. Vanderbilt intended for the village to generate income through commercial and residential building rentals while providing a high-quality lifestyle with modern amenities in a clean and attractive environment. Vanderbilt purchased the community of Best, North Carolina, where the village would be built, changing its name to Biltmore, North Carolina. This photograph shows the town as it appeared when Vanderbilt purchased it.

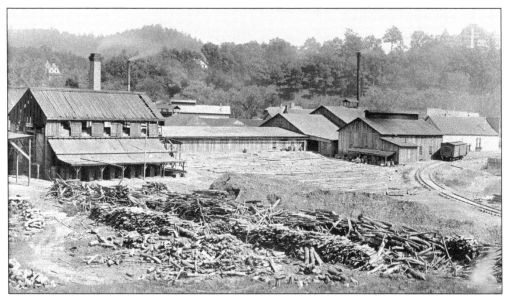

BILTMORE BRICK AND TILE WORKS, C. 1894. One of the first priorities for Biltmore Estate's creators was obtaining a steady supply of construction materials. In 1890, Richard Morris Hunt sent brick manufacturer O.B. Wheeler Jr. to Asheville to inspect clay pits on Biltmore Estate. The clay proved to be of good quality, so Vanderbilt established a brick and tile manufactory on the outskirts of Biltmore Village that by 1891 produced on average 38,000 bricks per day for use in construction.

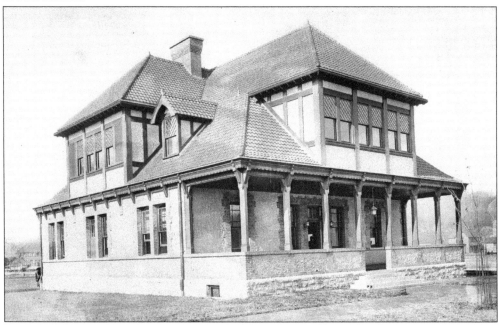

BILTMORE OFFICE BUILDING, 1895. This building, designed by Richard Morris Hunt and one of the first completed in Biltmore Village, contained the office of estate superintendent Charles McNamee. An attorney by profession, McNamee directed all estate operations from 1888 until 1904. Biltmore Estate has continuously maintained offices in this building located at One Biltmore Plaza since 1895.

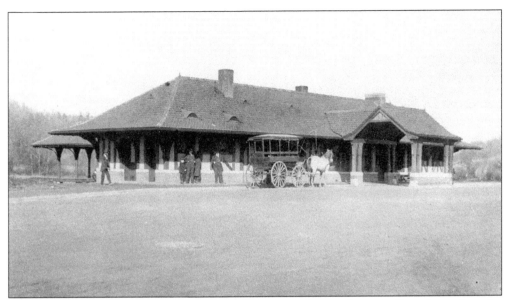

BILTMORE PASSENGER STATION, C. 1900. The original train depot in Best, located at the junction of the Spartanburg (South Carolina) and Asheville railroad lines, received building materials and furnishings destined for Biltmore House from all over the world. Vanderbilt had it replaced by this passenger station that was designed by Richard Morris Hunt. A new freight depot was built on the opposite side of the railroad tracks.

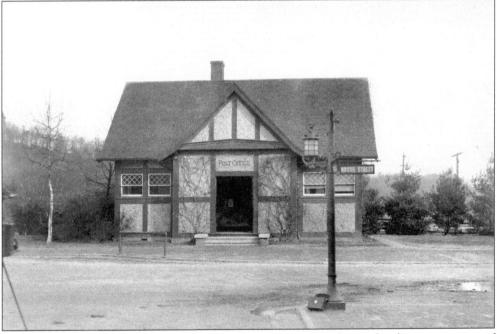

POST OFFICE, C. 1900. Richard Sharp Smith, supervising architect for the construction of Biltmore House, designed most of the buildings in Biltmore Village after Richard Morris Hunt's death in August 1895, including the Post Office. After work on Biltmore House ended, Smith opened a private architectural practice in Asheville. He designed many important buildings in the area, including churches, schools, civic buildings, and private residences.

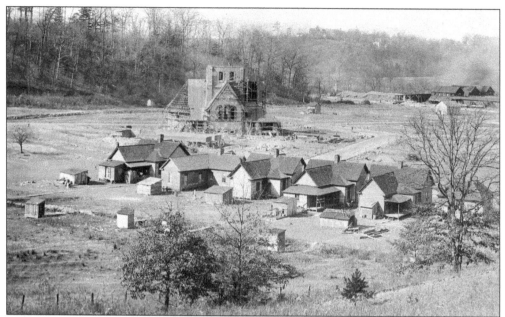

ALL SOULS' CHURCH UNDER CONSTRUCTION, LATE 1895–EARLY 1896. The central feature of Biltmore Village—architecturally, spiritually, and socially—was All Souls' Episcopal Church, designed by Richard Morris Hunt. In the foreground are temporary structures built to house construction workers. These were later replaced with rental cottages.

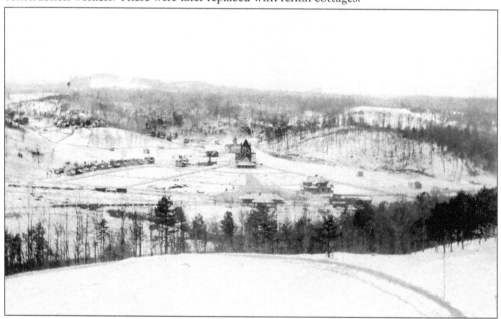

BILTMORE VILLAGE, MARCH 20, 1896. Richard Morris Hunt and Frederick Law Olmsted collaborated on the design of Biltmore Village. Initially, Hunt wanted to design village buildings in the French manner, in keeping with the style of Biltmore House, while Olmsted suggested an English manor style. Ultimately, they both embraced an English Tudor architectural style laid out in a French-inspired fan-shaped landscape, with All Souls' Church at the axis point. (Photograph by John C. Olmsted.)

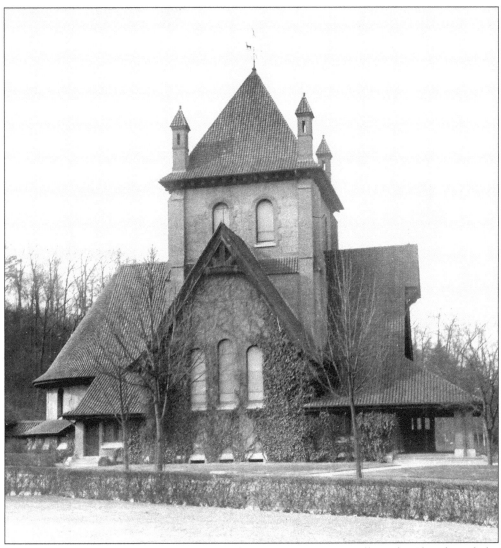

ALL SOULS' CHURCH, 1906. George Vanderbilt's influence on All Souls' Church and the community of Biltmore Village cannot be overestimated. A longtime member of the church wrote in 1933 that Vanderbilt "was an ardent student of theology as well as a deeply religious man. He aimed to benefit those who were in physical and mental need, hence he erected . . . the church he named All Souls'. . . . In order that the sittings might be free and the offerings made at its services devoted solely to missionary and charitable purposes, he defrayed all expenses connected with the maintenance of the church until the time of his death." (Marie Louise Boyer, *Early Days: All Souls' Church and Biltmore Village*, pp. 13–14, 1933.)

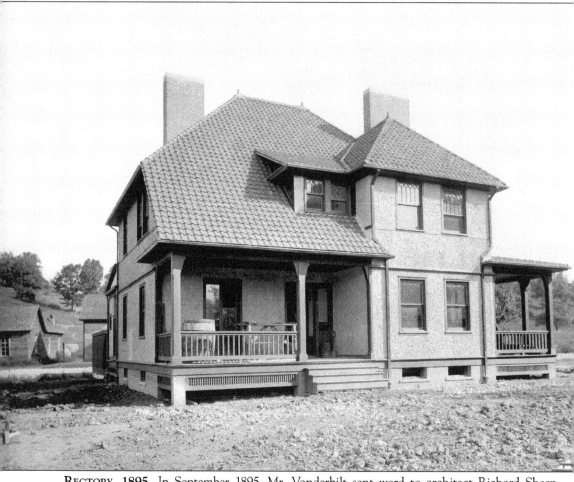

RECTORY, 1895. In September 1895, Mr. Vanderbilt sent word to architect Richard Sharp Smith to rush construction of a cottage in the village. This is the first cottage completed and is believed to be the parish rectory, located adjacent to All Souls' Church and next to the Sunday school. Late in 1896, estate superintendent Charles McNamee began the search for a permanent rector for All Souls' Church at Mr. Vanderbilt's request. Upon the recommendation of the Episcopal bishop of North Carolina, he and Vanderbilt traveled in February 1897 to Wheeling, West Virginia, to attend a service led by a promising young priest, the Reverend Rodney R. Swope. Vanderbilt was impressed, so he hired Dr. Swope to be the priest at All Souls' Parish. Swope served at All Souls' from 1897 to 1916.

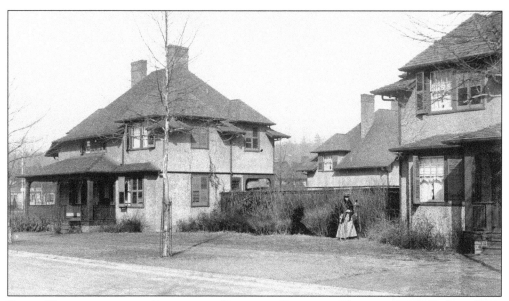

EDITH VANDERBILT WITH CAMERA ON TRIPOD IN BILTMORE VILLAGE, 1906. By June 1900, 24 cottages in four different plans were under construction. Rental costs for these six-room, one-bath cottages initially ranged from $18 to $20 per month depending on location and room size. The simplest and least expensive cottages were located on small lots adjacent to the railroad tracks. By 1906, construction was complete, and the village was fully occupied.

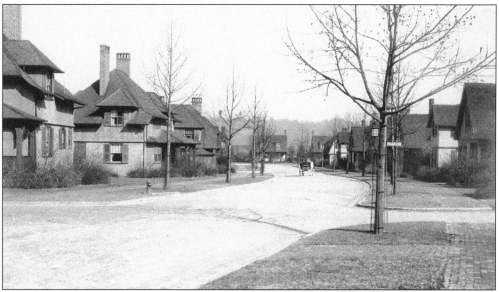

COTTAGES ON ALL SOULS' CRESCENT, BILTMORE VILLAGE, 1906. All of the cottages in Biltmore Village were available for rent. Residents included both visitors to the Asheville area who took out short-term leases and long-term renters. Edward Harding, assistant to estate superintendent McNamee, explained in a 1900 letter to a potential renter, "The village is well laid out and will prove . . . an attractive place of residence. . . . Applications for houses are numerous, and the social life of the village promises to be pleasant." (Letter from Edward J. Harding to Mr. C.G. Dresher of Germantown, Pennsylvania, May 4, 1900; letter in the Biltmore Estate Archives.)

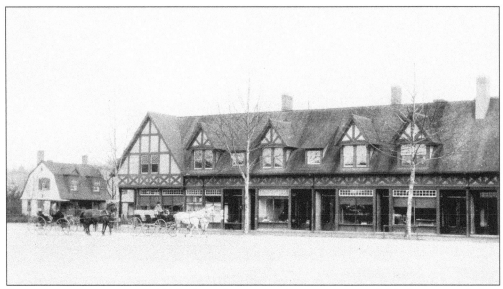

STORES AND APARTMENTS, 1906. Several commercial spaces were available for rent, including those located on the lower level of this building. On the second floor were apartments. Among the businesses in Biltmore Village were a general store, a meat market, a barbershop, an ice cream saloon, a drug store, a bakery, a laundry, and a tearoom. Mrs. Vanderbilt sold Biltmore Village, with the exception of All Souls' Church and the Clarence Barker Memorial Hospital, in 1920.

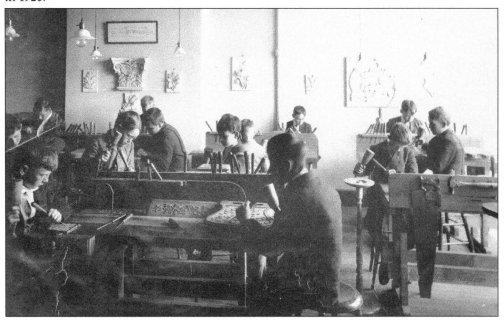

BOYS CLUB, C. 1901. Village resident Eleanor Vance organized a club in 1901 to teach boys woodcarving. Edith Vanderbilt provided financial assistance and encouraged Vance and needle worker Charlotte Yale to include girls in the club. In 1906, the Boys and Girls Club incorporated to form Biltmore Estate Industries. Among its products were hand-carved furnishings, hand-woven baskets, and homespun wool fabrics. Though Mrs. Vanderbilt sold Biltmore Estate Industries in 1917, it continued to operate as Biltmore Industries until the early 1980s.

Five

LIFE ON A COUNTRY ESTATE

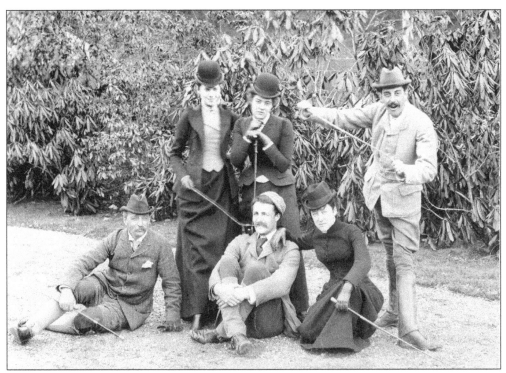

GEORGE VANDERBILT WITH FAMILY AND FRIENDS, PROBABLY 1892. George Vanderbilt was closer in age to many of his nieces and nephews than to his own brothers and sisters. During construction in 1892, Vanderbilt visited Biltmore Estate with, from left to right, the following: (seated) cousin-in-law Walter Rathbone Bacon, forester Gifford Pinchot, and cousin Virginia Barker Bacon; (standing) nieces Emily and Adele Sloane. George is standing on the right. They stayed at the Brick Farm House during their visit.

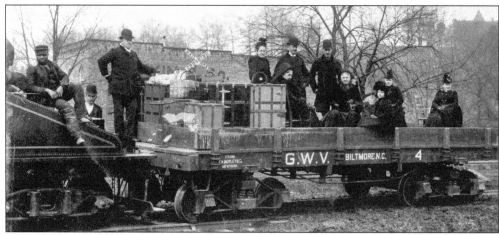

VANDERBILT PARTY NEAR THE BILTMORE STATION, DECEMBER 22, 1895. Though George Vanderbilt moved into Biltmore House from the Brick Farm House on October 26, 1895, he did not formally open the house until the Christmas holidays of that year, when most of his immediate family made their first visit. Among those pictured on a flatbed railroad car in Biltmore Village are George's sister Margaret Vanderbilt Shepard, standing behind a trunk; George Vanderbilt standing on the right; and George's mother, Mrs. William H. Vanderbilt, seated in front of him. The other individuals on the car are most likely relatives on George's mother's side of the family, while the car on the left carries porters and other workers. The Kenilworth Inn is in the background.

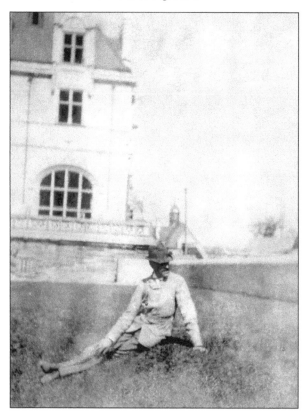

GEORGE VANDERBILT, C. 1897. Here, Mr. Vanderbilt relaxes on the sloped border of the bowling green on the South Terrace. Vanderbilt and his guests regularly took part in outdoor recreational activities such as lawn bowling, tennis, croquet, golf, and horseback riding while at Biltmore Estate.

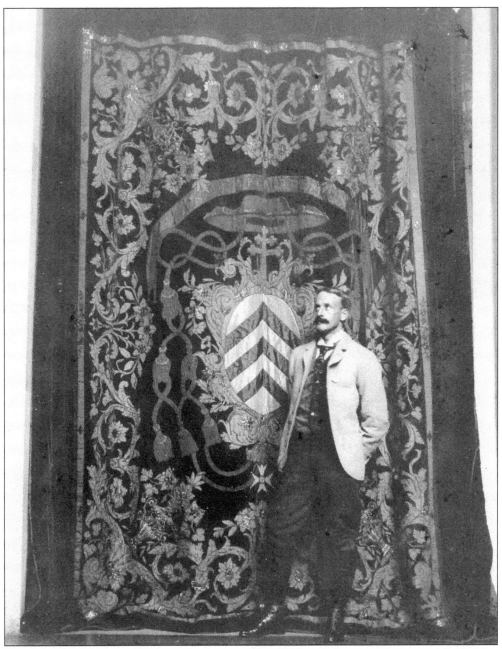

WILLIAM BRADHURST OSGOOD FIELD, C. 1900. Willie Field, one of George Vanderbilt's closest friends, visited Biltmore Estate on six occasions between 1895 and 1900. During the winter of 1897 and 1898, George and Willie traveled together in Europe and India. Field, a mechanical engineer by training, married Vanderbilt's niece Lila Sloane in 1902. He is standing in the Banquet Hall before a 17th-century wall hanging that once belonged to Cardinal Richelieu.

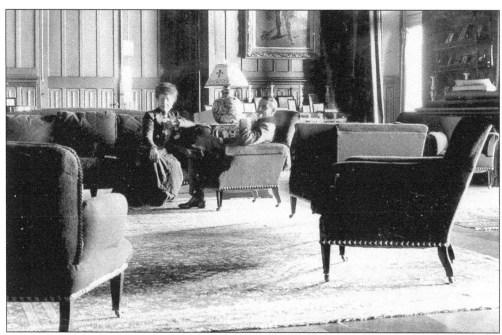

RELAXING IN THE TAPESTRY GALLERY, C. 1900. Guests often met in the Tapestry Gallery for afternoon tea, to converse, to play games, to listen to music, or to read. George Vanderbilt is seated on the right; the other individual is unidentified.

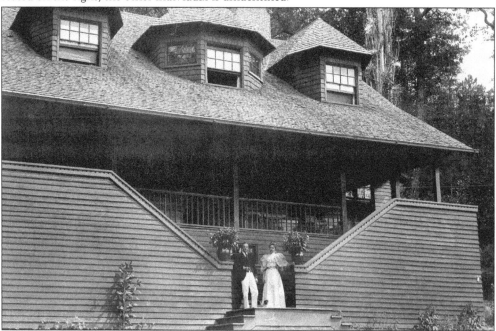

MR. AND MRS. JAMES A. BURDEN JR. AT RIVER CLIFF COTTAGE, JUNE 1896. George's niece Adele Sloane Burden and her husband, James ("Jay"), honeymooned at Biltmore Estate. George Vanderbilt built River Cliff Cottage at the same time Biltmore House was being constructed. He made the cottage available to the Burdens during their 10-day visit to Biltmore Estate. The cottage is no longer in existence.

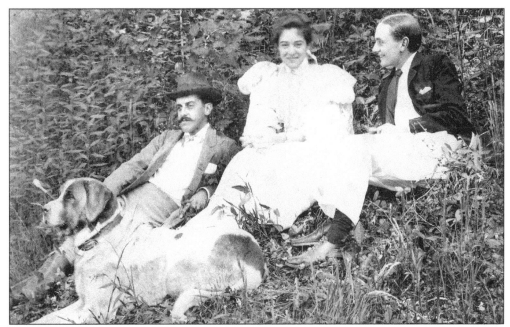

GEORGE VANDERBILT WITH ADELE AND JAY BURDEN, JUNE 1896. Adele and Jay Burden's wedding gained notoriety in the national press for being one of the most elaborate and expensive ever held in the United States. Following their stay at Biltmore Estate, Adele and Jay Burden continued their honeymoon with a lengthy trip around the world.

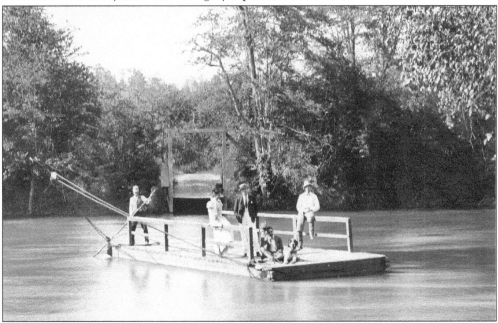

CROSSING THE RIVER, JUNE 1896. A ferry operator transports George Vanderbilt (seated next to a dog), the Burdens (standing on the left), and an unidentified man across the French Broad River on one of two ferries installed on the river. This is most likely the upper ferry located near River Cliff Cottage, while the lower ferry was located several miles down-river near the farm village.

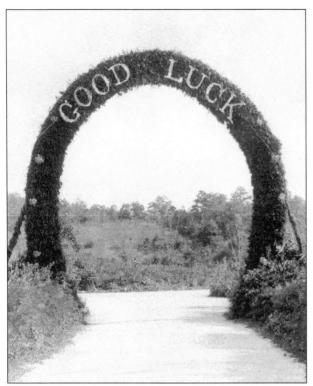

"GOOD LUCK" HORSESHOE ON BILTMORE ESTATE, OCTOBER 1, 1898. George Vanderbilt's marriage to Edith Dresser was cause for much celebration on Biltmore Estate. Employees erected this floral arch to welcome Mr. and Mrs. Vanderbilt to the estate after their wedding in Paris and honeymoon in Europe.

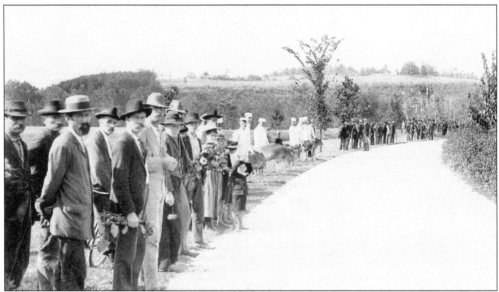

ESTATE WORKERS AND FAMILIES, OCTOBER 1, 1898. Of the arrival of the Vanderbilts to Biltmore Estate, *The Asheville Daily Citizen* wrote, "At the arch representatives from the agricultural departments of the estate were massed, each group bearing a device typical of their labor. The men of the Dairy wore suits of white duck and each one held the halter strap of a Jersey calf. The nurserymen tossed flowers to the bride as the carriage passed." Celebrations for the Vanderbilts and estate workers and their families continued well into the night with fireworks and music in front of Biltmore House.

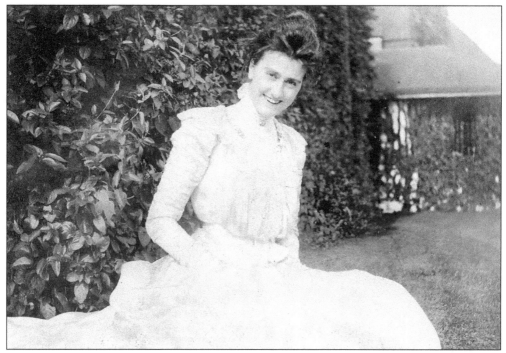

EDITH VANDERBILT, C. 1900. Though only 25 when she and George Vanderbilt married, Edith quickly gained the respect and admiration of the community, including not only fashionable members of local society but also the community of estate residents. Mrs. Vanderbilt frequently visited workers and their families across the vast estate, delivering food and medicine when needed, bearing gifts when babies were born, and providing educational and spiritual guidance.

GEORGE VANDERBILT AND GROOM IN FRONT OF BILTMORE HOUSE, SEPTEMBER 25, 1901. Edith Vanderbilt, an amateur photographer, took this photograph of her husband. She was obviously pleased with her abilities at this newly discovered hobby, for she wrote on the back of this photograph, "Taken and developed and printed, without help."

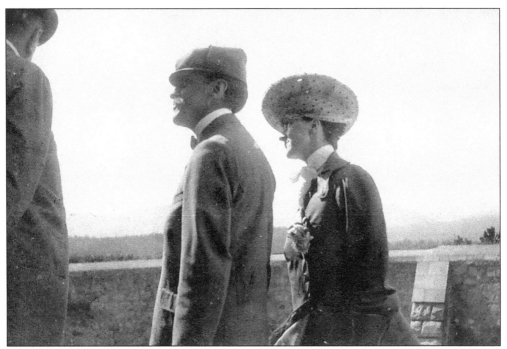

MR. AND MRS. VANDERBILT, C. 1900. In this photograph, George and Edith Vanderbilt stand on the South Terrace overlooking the Deer Park and the beautiful Blue Ridge Mountains in the distance.

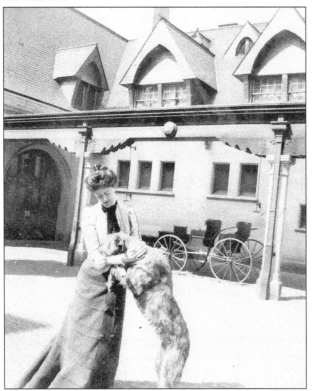

EDITH VANDERBILT, C. 1900. As mistress of Biltmore House, Mrs. Vanderbilt was responsible for day-to-day management of the household. She met each morning with the chef to plan the day's menus and coordinated all events and activities with the housekeeper and butler. Here, she plays with one of the family's pets in the stable courtyard.

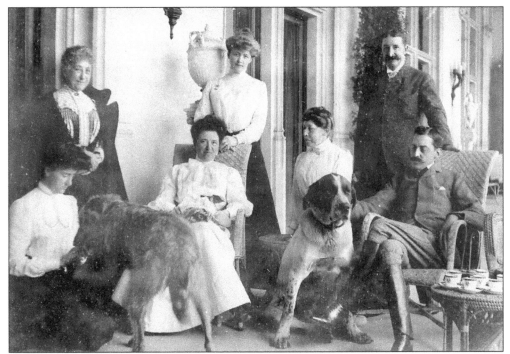

AFTERNOON TEA ON THE LOGGIA, SEPTEMBER 1900. A large contingent of family and friends visited the Vanderbilts in September 1900 to meet the newest member of the family, Cornelia, who was born in August of that year. Pictured from left to right are Edith Vanderbilt, Mlle. Marie Rambaud (Edith Vanderbilt's former chaperone), Lila Vanderbilt Webb (George's sister), Effie Caesar (George's cousin), an unidentified woman and man, and George Vanderbilt.

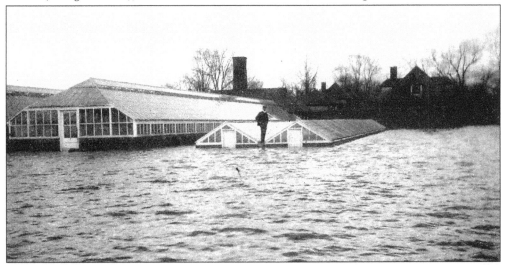

FLOOD WATERS ON BILTMORE ESTATE, 1901. Located at the confluence of the French Broad and Swannanoa Rivers, the bottomlands on Biltmore Estate were vulnerable to repeated flooding. In 1901, *The Asheville Daily Citizen* wrote, "Biltmore is not longing for another flood; the last one is still rendering things very uncomfortable." The largest flood of the 20th century in Western North Carolina took place in July 1916, destroying these greenhouses behind the Truck Farm.

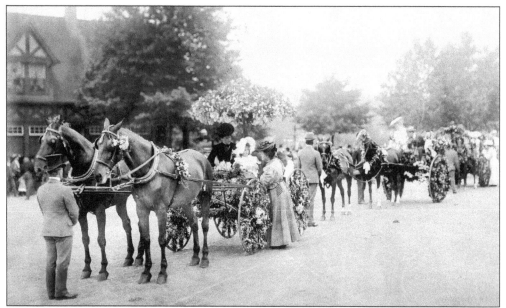

EDITH AND CORNELIA VANDERBILT LEADING A CARRIAGE PARADE, MAY 25, 1905. Festivities celebrating spring took place for several years in Biltmore Village with the Vanderbilts and residents of the estate and village participating. These celebrations had their beginnings in medieval Europe, when rural peasants and villagers commemorated the end of winter and the birth of a new season.

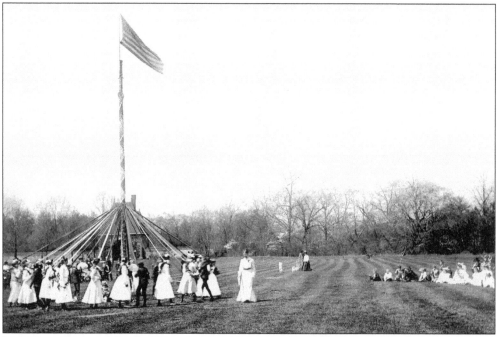

MAY POLE DANCE, MAY 1, 1906. One of the festivities of May Day was the May Pole Dance. In 1906, children from the Biltmore Parish Day School performed the May Pole Dance on the Biltmore green, located just outside the entrance to Biltmore Estate. It was part of a series of dramatic skits drawn from English legends performed that day for the community.

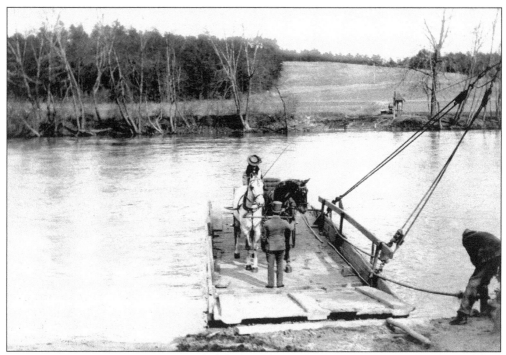

EDITH VANDERBILT, 1906. Mrs. Vanderbilt, accompanied by a groom, crosses the French Broad River on the lower ferry during a photography expedition.

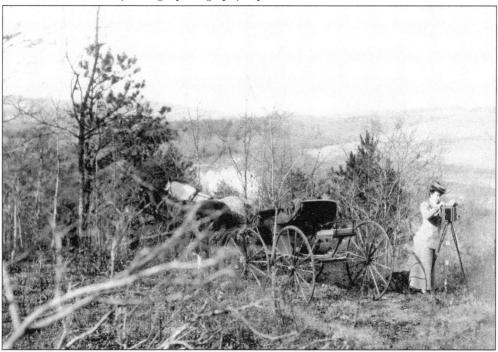

EDITH VANDERBILT, 1906. In this view, an unidentified photographer captures Mrs. Vanderbilt setting up her camera in the woods above the banks of the French Broad River. This photograph was taken the same day as the previous one.

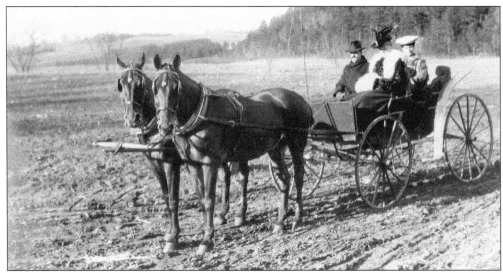

GEORGE VANDERBILT AND UNIDENTIFIED GUESTS, 1906. Vanderbilt enjoyed showing off his property, particularly the land management operations that were widely heralded as the most innovative in the country. Secretary of Agriculture Morton, who visited in 1896, said, "It is not possible to describe . . . the vast object-lessons in forestry, horticulture, road-building, gardens, dairying and general farming which Mr. Vanderbilt is inculcating amidst the mountains of North Carolina." (*Asheville Hotel and News Reporter*, April 4, 1896.)

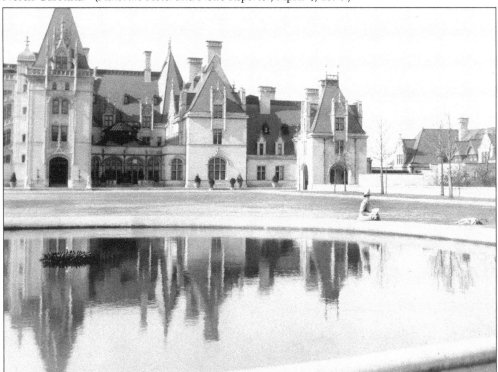

READING BY THE FOUNTAIN, 1905. The woman in this photograph is most likely Edith Shepard Fabbri, George Vanderbilt's niece who visited Biltmore Estate with her husband, Ernesto Fabbri Jr., and their children in late December 1905.

George Vanderbilt and Friend at the Creamery, 1906. The Creamery, located across the road from the Dairy Barn, was a favorite stop for estate guests who might enjoy a taste of ice cream during their visit. George Vanderbilt is on the left; the gentleman with him is unidentified.

Walking Toward the Farm Village, 1906. For decades, the farm village was the center of estate life for agricultural workers and their families, some of whom lived and worked on Biltmore Estate for generations. The Horse Barn, which stabled workhorses, was also a gathering place for estate residents who attended classes and worship services and held fall harvest fairs and other social gatherings within the barn complex.

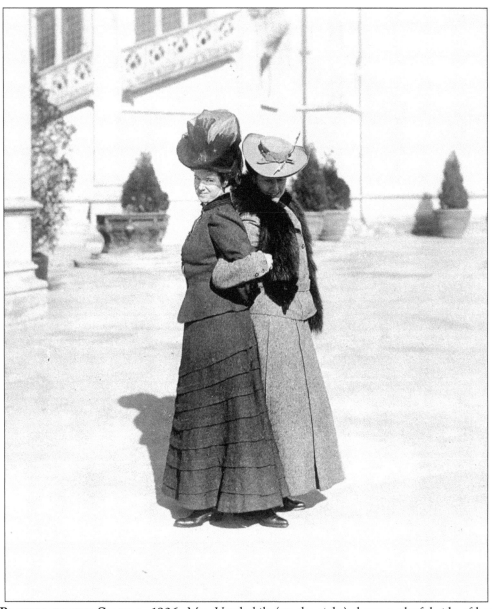

PLAYING TO THE CAMERA, 1906. Mrs. Vanderbilt (on the right) shows a playful side of her personality in this photograph. The woman with her is believed to be Edith Shepard Fabbri, George Vanderbilt's niece and Edith Vanderbilt's close friend. Mrs. Vanderbilt was known among friends and family for her sense of humor, and she was especially fond of limericks. In the Biltmore *Nonsense Book*, a collection of poems and sketches created by family and friends starting in October 1898, this limerick appears, dedicated to Edith:

There was a fair maid called Edith
Who for long was considered a Myth
She came to Biltmore
For us all to adore
Our American beauty Edith.

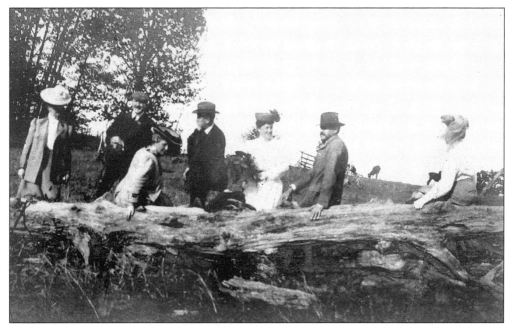

EXPLORING THE ESTATE, MAY 1906. Among the guests at a house party held in May 1906 was William H. Moody (believed to be the second person on the left). At the time of his visit, Moody was U.S. attorney general serving President Theodore Roosevelt. In December 1906, Roosevelt appointed Moody to the U.S. Supreme Court. Mr. Vanderbilt is seated on the right.

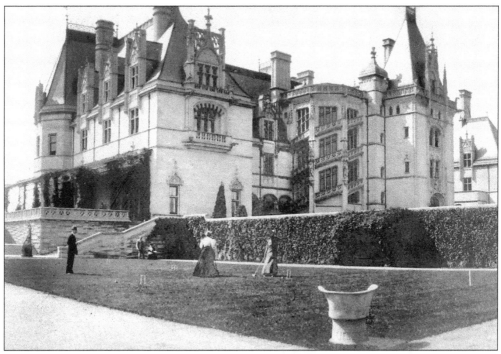

CROQUET ON THE GARDEN TERRACE (ITALIAN GARDEN), MAY 1906. This photograph was taken during the same house party as the photograph above.

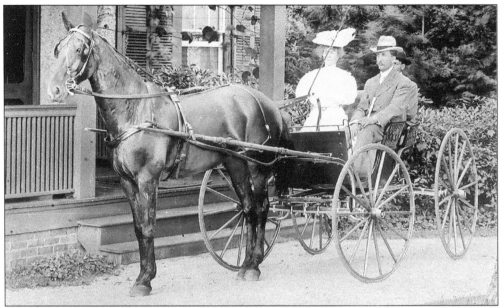

MR. AND MRS. CHAUNCEY BEADLE, 1906. Beadle, a Canadian by birth who studied botany at Cornell University, came to Biltmore in 1890 while in his mid-20s to assist Frederick Law Olmsted with landscaping. Here, Chauncey and Margaretta Beadle (in the front seat of the carriage) are pictured in front of Eastcote, the home Vanderbilt built for them in the early 1900s. Vanderbilt provided residences for most department heads on Biltmore Estate. (Photograph donated by Jeanette Angel.)

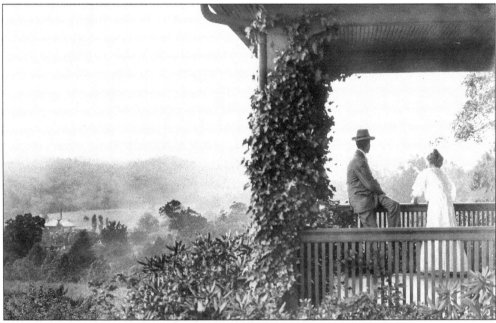

THE BEADLES AT EASTCOTE, 1906. Beadle served first as nursery manager and then for many years as estate superintendent. He retired in 1945 after 55 years of service to Biltmore Estate. Of his time at Biltmore, Beadle liked to say, "I came for a month and stayed for a lifetime." He lived at Eastcote until his death in 1950. (Photograph donated by Jeanette Angel.)

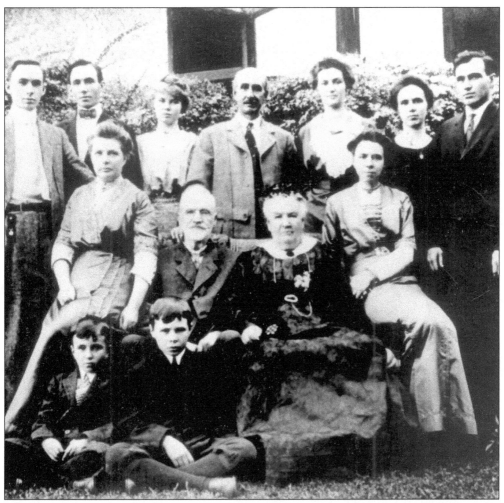

THE HENRIE AND ARTHUR FAMILIES ON BILTMORE ESTATE, C. 1912. Mr. and Mrs. James L. Henrie (seated in the center of the photograph) came to Western North Carolina in 1897 to establish a private dairy. They hired George Stevenson Arthur (standing directly behind them), who was from the same Scottish town from which they had emigrated, to assist them. Mr. Arthur married the Henries' daughter Isabella (seated next to her father), and not long afterward was hired to manage the vegetable gardens and greenhouses at the Truck Farm, also known as the Market Garden, on Biltmore Estate. The Henrie and Arthur families are gathered in this photograph at the market gardener's cottage, where the Arthurs lived from around 1900 to 1914. George Garret Arthur (back row, far right) was one of the first members of the Boys Club in Biltmore Village and later served as superintendent of Biltmore Estate Industries. (Photograph donated by Ginger Arthur Rozner.)

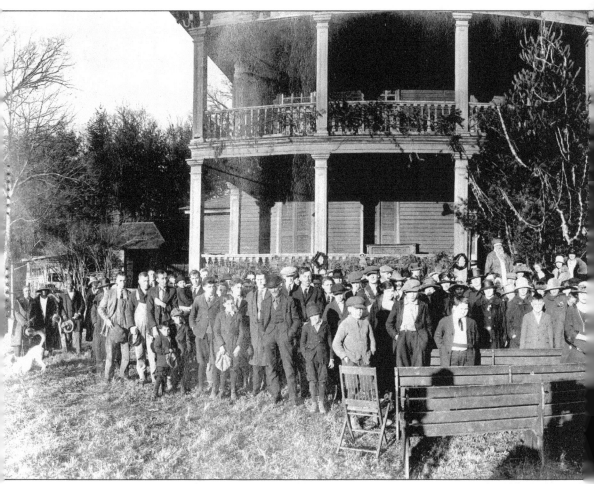

BILTMORE ESTATE CHRISTMAS PARTY, 1916. The most important event for the estate community was the annual Christmas party. The Vanderbilts gave gifts to all employees and their families— toys and candy for the children and practical gifts like clothing and dress fabric for the adults. Parties were most often held in the Banquet Hall at Biltmore House, though at

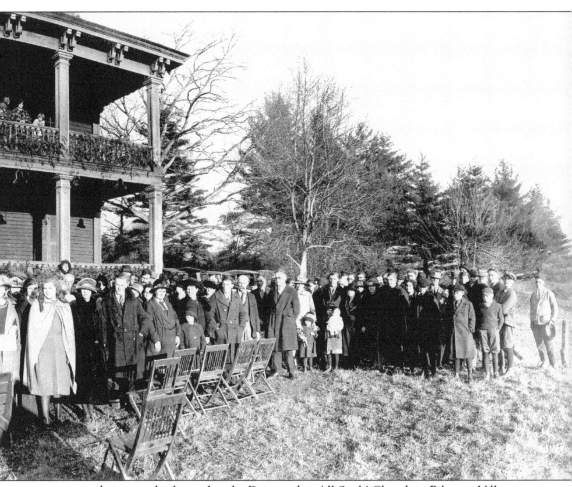

various times they were also located at the Dairy and at All Souls' Church in Biltmore Village. In 1916, the party was held at Antler Hall, a home predating the creation of Biltmore Estate that was converted to apartments for dairy workers and their families. The weather was so warm that year that the party was held outdoors. Food, music, and dancing usually followed gift giving.

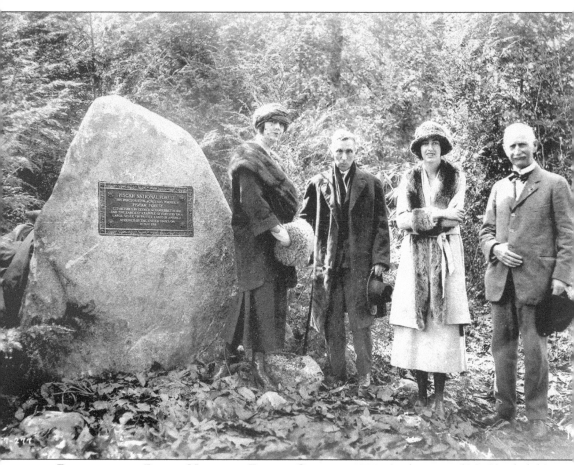

DEDICATION OF PISGAH NATIONAL FOREST, OCTOBER 1920. At the time of Mr. Vanderbilt's death in 1914, he was engaged in negotiations to sell over 80,000 acres of land to the federal government in hopes that it would become a forest preserve. Two months after she became a widow, Mrs. Vanderbilt resumed negotiations, though she offered the land at only $5 per acre, considerably less than the original asking price. In a letter to Secretary of Agriculture David Franklin Houston, she explained, "I make this contribution towards the public ownership of Pisgah Forest with the earnest hope that in this way I may help to perpetuate my husband's pioneer work in forest conservation, and to insure the protection and the use and enjoyment of Pisgah Forest as a national forest, by the American people for all time." Pisgah National Forest was officially dedicated to the memory of George Vanderbilt at a ceremony held six years later. From left to right are Edith Vanderbilt, governor of North Carolina Locke Craig, Cornelia Vanderbilt, and secretary of the Appalachian Park Association George S. Powell.

Six

ESCAPE TO NATURE

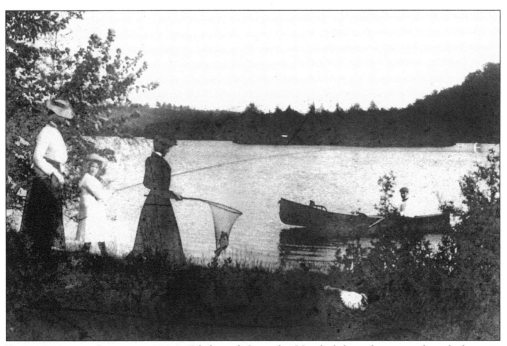

FISHING IN THE LAGOON, 1906. Edith and Cornelia Vanderbilt and two unidentified guests enjoy fishing and rowing at the Lagoon in this photograph, taken when Cornelia was five years old. Mr. Vanderbilt stocked the Lagoon with large-mouth bass, one of which, caught here in Mrs. Vanderbilt's net, is destined for the banquet hall table.

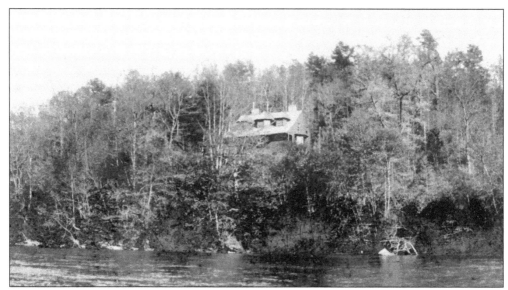

RIVER CLIFF COTTAGE, 1906. Situated on the banks of the French Broad River three miles from Biltmore House, River Cliff Cottage provided guests a secluded yet comfortable mountain retreat. Frederick Law Olmsted used River Cliff Cottage as a temporary residence on several occasions, often accompanied by his wife and adult children. Two of George Vanderbilt's nieces—Adele Sloane Burden and Edith Shepard Fabbri—stayed in River Cliff Cottage in the late 1890s during their honeymoons.

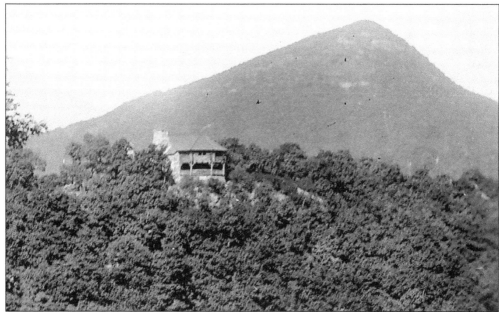

BUCK SPRING LODGE, C. 1920. In the last quarter of the 19th century, wealthy individuals built rustic camps in New York's Adirondack Mountains to escape the bustle of life in the city. Gaining inspiration from the Adirondack lodges, George Vanderbilt decided to build his own lodge at nearby Mount Pisgah. Buck Spring Lodge provided Vanderbilt and his guests a base camp from which they hunted, fished, and explored. (Photograph donated by Mrs. William Todd Ashby.)

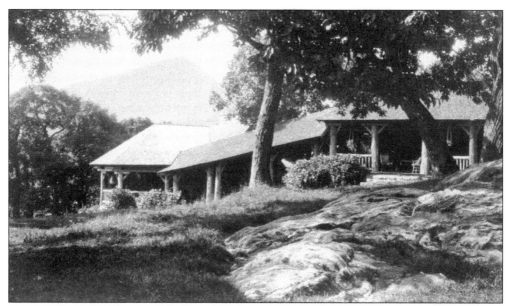

BUCK SPRING LODGE, C. 1910. Designed by architect Richard Howland Hunt, Buck Spring Lodge was built of native logs and stone. It was made up of three connected buildings: the main lodge, a "mid-way building," and a kitchen and dining building. Like Biltmore House, Buck Spring Lodge incorporated state-of-the-art amenities like electricity, telephones, and indoor plumbing.

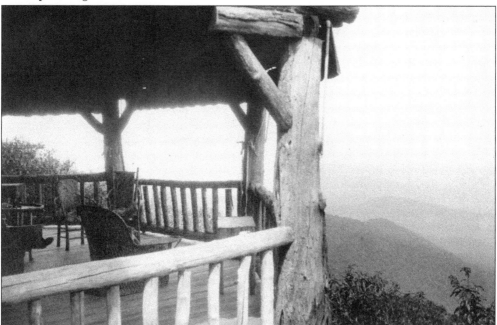

BUCK SPRING LODGE, C. 1920. This verandah afforded visitors spectacular mountain views. George Vanderbilt originally specified that only native chestnut logs be used in construction; however, finding enough chestnut timbers in the proximity proved difficult, so he consented to any species of tree as long as the logs were large enough. (Photograph donated Mrs. William Todd Ashby.)

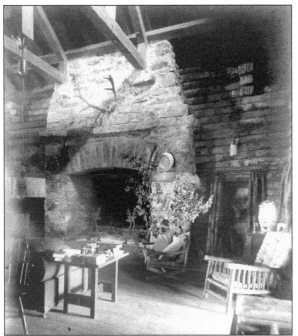

INTERIOR, BUCK SPRING LODGE, c. 1920. To maintain a rustic ambience inside Buck Spring Lodge, wood-burning fireplaces like the one shown here in the living room heated interior spaces instead of a central heating system. Caretakers lived at the site of Buck Spring Lodge year-round in a cabin located nearby. When the Vanderbilts and guests were in residence, a cook and other staff would also be on hand to attend to their needs. (Photograph donated by Mrs. William Todd Ashby.)

INTERIOR, BUCK SPRING LODGE, C. 1920. This view of the living room also shows the balcony and library on the second floor. In 1914, Edith Vanderbilt sold most of Pisgah Forest to the federal government, retaining Buck Spring Lodge and 471 acres surrounding it. In 1958, Edith's descendants sold the entire Buck Spring tract to the state, which transferred ownership to the United States to be incorporated into the Blue Ridge Parkway. Buildings at the site were razed in the early 1960s. (Photograph donated by Mrs. William Todd Ashby.)

SCHENCK'S CABIN, JULY 1, 1901.
Dr. Carl Schenck, Biltmore's
forester from 1895 to 1909, often
served as Vanderbilt's guide
on camping expeditions. The
Schenck cabin in the Pink Beds,
which were named for the lush
rhododendron and mountain
laurel thickets in that vicinity of
Pisgah Forest, served as a meeting
place. The Schencks lived in
this cabin in the summer when
the Biltmore Forest School, the
nation's first school of forestry,
which was founded by Schenck,
was in operation.

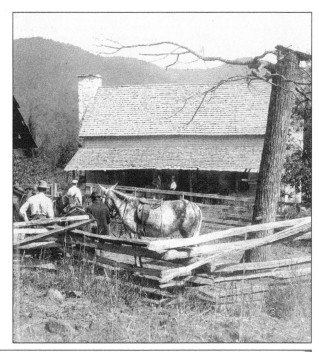

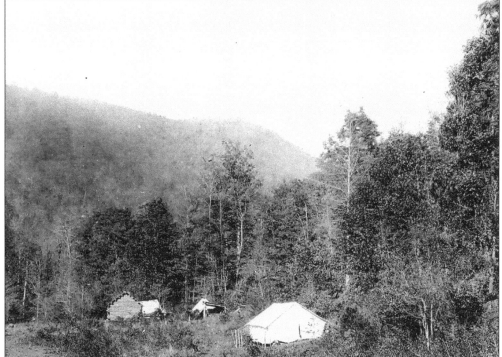

VANDERBILT CAMPSITE, JULY 1901. Dr. Schenck not only led expeditions into Vanderbilt's
mountains but also managed all arrangements, including set up of campsites like this one in the
Pink Beds. Excursions were usually multi-day affairs, with the campsite being moved to a new
location every few days. A crew of forest rangers ensured that adequate food for men and horses
and other necessary supplies were delivered to each campsite in advance.

95

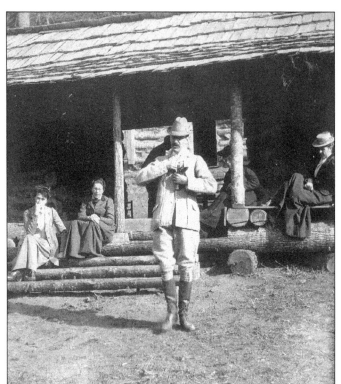

"THREE-DAY CAMP," 1901.
Around 1900, Vanderbilt decided to build a second lodge near Looking Glass Rock in Pisgah Forest. He contacted Dr. Schenck in 1901 saying that he would soon be visiting the proposed site of the lodge and needed a cabin in which to reside. Schenck's workers built a new cabin in three days, earning it the nickname "Three-Day Camp." George Vanderbilt stands in the foreground of this photograph, while Edith Vanderbilt is seated at the far left. Looking Glass Lodge was never built.

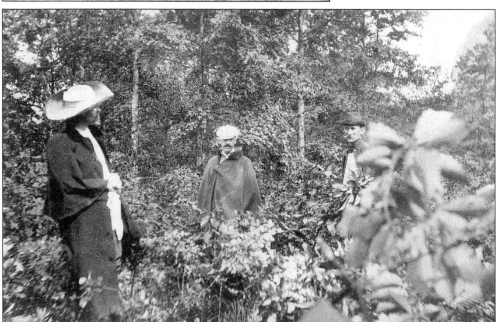

IN THE WOODS, 1901. George Vanderbilt and his mother first visited Western North Carolina in order to meet with Dr. Samuel Westray Battle, a nationally known physician who helped establish Asheville as a health resort. Dr. Battle and Mr. Vanderbilt not only maintained a professional relationship over the years, but they also enjoyed a long-lasting friendship. Pictured from left to right are Dr. Battle, George Vanderbilt, and Dr. Carl Schenck.

GEORGE VANDERBILT AT LOOKING GLASS ROCK, 1901. Inscribed on the back of this photograph is "The Lord of Looking Glass Rock." A giant granite dome in Transylvania County, Looking Glass Rock is now part of Pisgah National Forest.

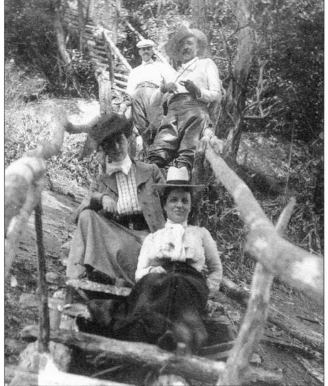

"THE LADDER," 1901. In this photograph, from top to bottom, are George Vanderbilt, Dr. Westray Battle, Edith Vanderbilt, and Marion Olmsted. They pose on a series of ladders installed on Looking Glass Rock to enable visitors to reach the summit, where they were guaranteed spectacular views of the surrounding Blue Ridge Mountains.

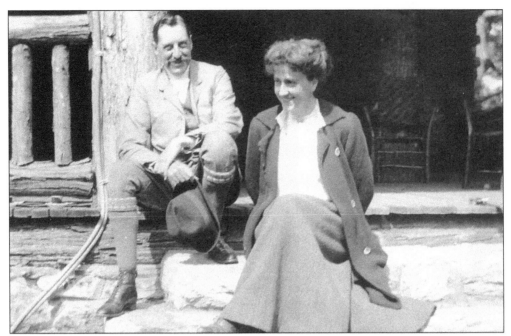

MR. AND MRS. VANDERBILT AT BUCK SPRING LODGE, C. 1912. The Vanderbilts' marriage was a happy one. In 1912, Mr. Vanderbilt wrote a recently engaged nephew, "Today is Ediths [*sic*] and my wedding day and the fourteen years seem all like a moment. A happy marriage is the true fruition of life and we both wish yours may be thus." (George Vanderbilt to Vanderbilt Webb, June 1, 1912; Vanderbilt Webb Papers, Shelburne Farms Collection, Shelburne, Vermont.)

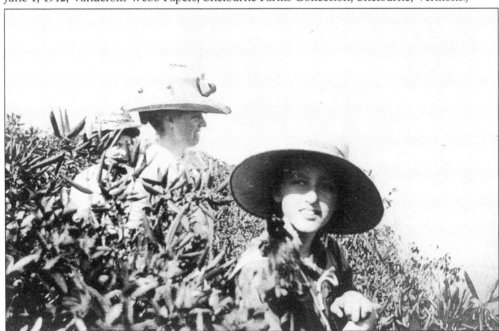

CORNELIA VANDERBILT IN A RHODODENDRON THICKET, C. 1912. Cornelia continued the tradition of enjoying nature and outdoor recreation that her parents established. Here she is pictured with unidentified friends near Mount Pisgah.

Seven

TARHEEL NELL

GEORGE VANDERBILT WITH DAUGHTER CORNELIA, SEPTEMBER 30, 1900. George and Edith Vanderbilt's only child was born at home on August 22, 1900. Of her arrival, *The Spartanburg Journal* in South Carolina wrote, "A new star has appeared at famous Biltmore, and the charming mistress of this most gorgeous home is smiling upon her first born, a tiny girl called Cornelia Stuyvesant Vanderbilt, and the world shares in her new found happiness."

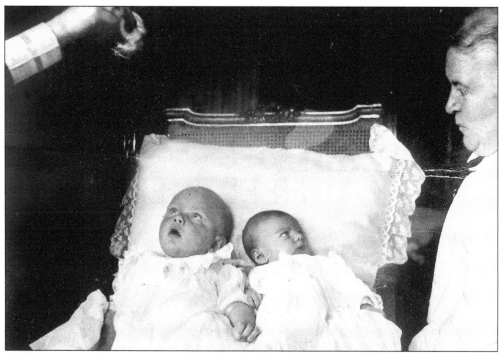

BABIES AT BILTMORE, 1900. Soon after Cornelia's birth, a steady stream of visitors made their way to Biltmore to meet the new arrival. Among those who visited were Cornelia's first cousin John Nicholas Brown, the baby on the left in this photograph. John Nicholas was the son of Edith Vanderbilt's sister, Natalie Dresser Brown. Cornelia's nanny is on the right.

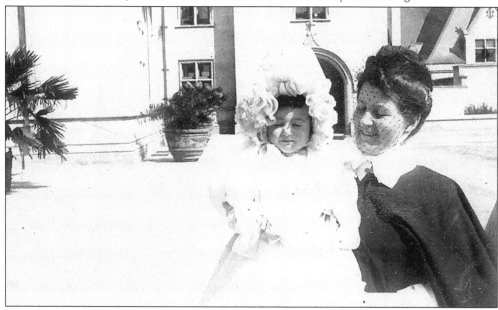

CORNELIA AND A NANNY, 1901. Edith Vanderbilt most likely took this photograph of her daughter being held by a nanny. Like her father, Cornelia was a world traveler at a very early age. She and her parents traveled to Paris to attend the 1900 World's Fair when Cornelia was only three months old.

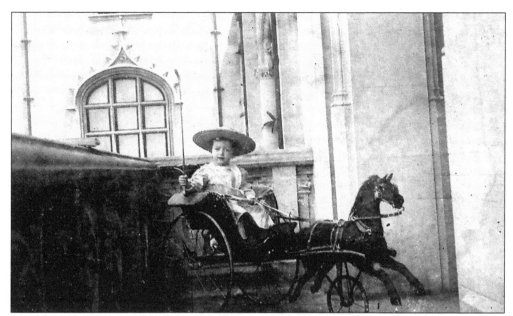

CORNELIA AT PLAY, C. 1902. Cornelia's playground was Biltmore Estate, and her playmates were frequently the children of estate workers, many of whom in oral history interviews recounted attending birthday and costume parties in Biltmore House, riding horses, and climbing trees with Cornelia. This photograph was taken on the terrace of the Library Den facing the Music Room.

CORNELIA VANDERBILT, 1903. In the Biltmore *Nonsense Book*, a collection of poems and drawings created by Mr. Vanderbilt and his guests at Biltmore House, George Vanderbilt wrote:

There once was a dear little Girlie
With hair so soft and curly,
"The pleasure is mine!"
With a bow so fine
Would lisp this dear little Girlie.

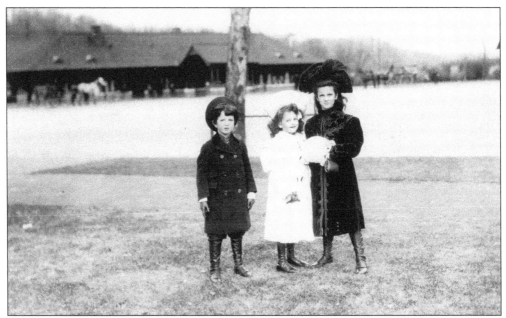

CORNELIA VANDERBILT WITH TERESA AND ERNESTO FABBRI JR., CHRISTMAS 1905. Cornelia Vanderbilt had 11 sets of aunts and uncles, 29 first cousins, and 75 second cousins. Many of them visited her at Biltmore. This photograph was taken in late December while Cornelia and two of her many cousins explored Biltmore Village. Behind them is the Biltmore Passenger Station.

CORNELIA VANDERBILT AND A ST. BERNARD, C. 1910. The Vanderbilts had numerous pets over the years, including a St. Bernard named Cedric who sired a second generation of dogs that also appear frequently in archival photographs. The pedigree of their Irish wolfhound Ivan could be traced to Russia, Germany, and Prussia. A parrot named Coco made her home in the Winter Garden. Cornelia even had a pet skunk at one time.

CORNELIA VANDERBILT IN FRONT OF BILTMORE HOUSE, C. 1910. Cornelia attended elementary school at the Parish Day School in Biltmore Village. George Vanderbilt originally built the school for the children of estate employees, but it was so progressive that it also attracted students not associated with Biltmore Estate.

CORNELIA VANDERBILT ON A MULE, 1911. Cornelia was an active and athletic child who, like her mother, excelled at riding both horses and mules. Biltmore Estate and the surrounding mountains contained numerous riding trails.

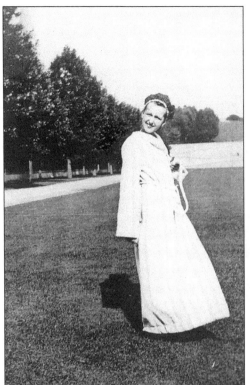

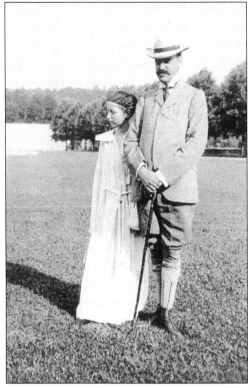

GOING FOR A SWIM, 1910. This delightful series of photographs taken by Edith Vanderbilt shows Cornelia, accompanied by her father, during a swim in the fountain in front of Biltmore House. In the wintertime, Cornelia and friends would often ice skate on the frozen pool.

CORNELIA UNDER THE TULIP POPLARS, C. 1913. Here, Cornelia is captured by the camera in a quiet moment, knitting while seated underneath the allée of poplar trees on the Esplanade. Edith Vanderbilt most likely took this picture of her daughter.

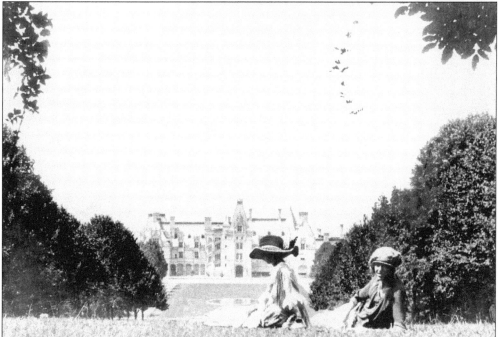

LOUNGING ON THE VISTA, C. 1915. Little is known about Cornelia's education between 1909, when the Biltmore Parish Day School closed, and 1915, when she enrolled at a private boarding school. Here, Cornelia (on the right) and a friend pose at the Vista above Biltmore House.

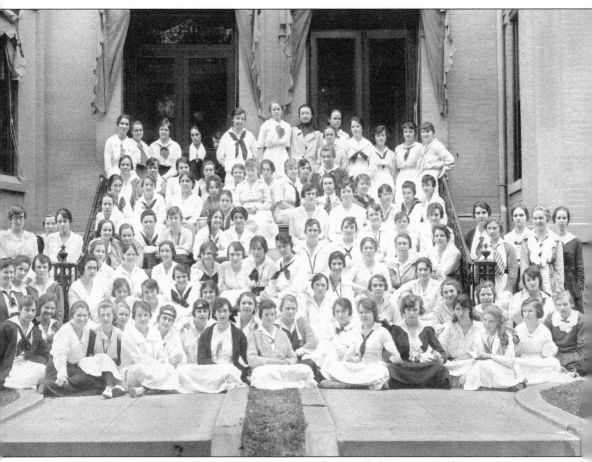

CLASS PHOTO, C. 1915. In February 1915, Cornelia enrolled in Miss Madeira's, a prestigious private boarding school for girls in Washington, D.C., that was originally located on DuPont Circle. In the school yearbook, her classmates noted Cornelia's pleasant-sounding voice, predicting that she would become a "Professor of Elocution and Voice Culture." She is seated in the front row, fourth from the right. Cornelia graduated in 1919.

Eight

THE ROARING TWENTIES

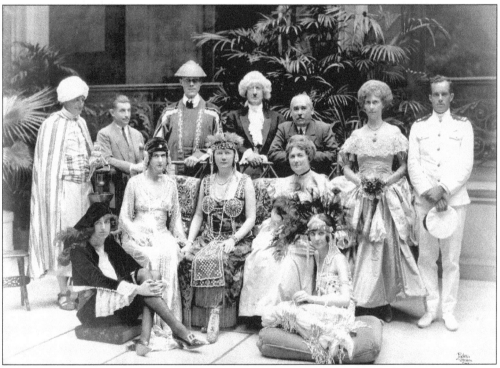

MASQUERADE BALL IN BILTMORE HOUSE, AUGUST 1921. Mrs. Vanderbilt gave a costume party to celebrate Cornelia's 21st birthday and her coming-out into society. Both Cornelia (seated on a floor cushion on the left) and Mrs. Vanderbilt (on the couch behind Cornelia) wore costumes meant to reflect the French renaissance style of Biltmore House. This photograph was taken in the Winter Garden, where guests danced to the tunes of the Garber-Davis Orchestra from Atlanta.

EDITH VANDERBILT AS CLEOPATRA, C. 1923. *Tableaux vivants*, which were staged representations of famous historic or artistic scenes, were especially popular in the late 19th and early 20th centuries. Here, Edith Vanderbilt and two unidentified friends are photographed in the Tapestry Gallery while representing a scene from Shakespeare's *Antony and Cleopatra*.

EDITH VANDERBILT AS A PEACOCK, C. 1923. In this *tableau vivant* performed in the Library, Edith Vanderbilt is dressed as a peacock. The peacock symbolizes many things, including eternal life and vanity. Mrs. Vanderbilt may have performed this *tableau vivant* on the same evening that she portrayed Cleopatra to create a sense of thematic unity in her presentation, for the peacock is often associated with Cleopatra and other empresses.

EDITH VANDERBILT, 1924. Mrs. Vanderbilt was extremely active in civic affairs at the local, state, and national level. During World War I, she headed the Asheville chapter of the British-American War Relief Society. She also campaigned heavily for adult literacy, and in the early 1920s, she served as the first female president of the North Carolina State Fair and as president of the North Carolina Agricultural Society. After her 1925 marriage to Sen. Peter Gerry of Rhode Island, Edith was elected president of the Women's Congressional Club, an organization for the wives of U.S. senators and representatives. In this photograph, she wears clothing made from Biltmore "homespun," which was hand-woven fabric produced by Biltmore Industries. Mrs. Vanderbilt frequently promoted Biltmore Industries in Washington and New York, generating interest in its products. Edith Vanderbilt Gerry died in Providence, Rhode Island, in 1958.

CORNELIA VANDERBILT, 1924. Cornelia and Edith Vanderbilt frequently spent time at their K Street residence in Washington, D.C. While there in 1923, Cornelia met John Francis Amherst Cecil, a diplomat stationed at the British Embassy. Ten years older than Cornelia, Cecil was one of a group of eligible diplomats known in the capitol's social circles as the "British bachelors." At a reception a few months after they met, Cornelia and John announced their engagement. They also made public their plans to wed at All Souls' Church in Biltmore Village the following April. *The Asheville Citizen* noted on April 29, 1924, that the announcement "caused a stir of interest all over the United States and England . . . as it brings together two families prominent in public affairs in their respective countries."

THE HONORABLE JOHN FRANCIS AMHERST CECIL, 1924. The third son of Lord Cecil and the Baroness Amherst of Hackney, John Cecil was a descendant of William Cecil, Lord Burghley (1520–1598), who was lord high treasurer to Queen Elizabeth I. Cecil grew up in the English countryside of Norfolk and attended Eton School as a child. He then studied history and international law at the New College of Oxford University. During an 11-year career as a British diplomat, Cecil served in Egypt, Spain, and Czechoslovakia before being stationed in Washington. At the time of his engagement to Cornelia Vanderbilt, Mr. Cecil was first secretary at the British embassy. Shortly before his marriage, he resigned his position, announcing that after the wedding he would make Biltmore his primary residence and would take an active role in managing the estate.

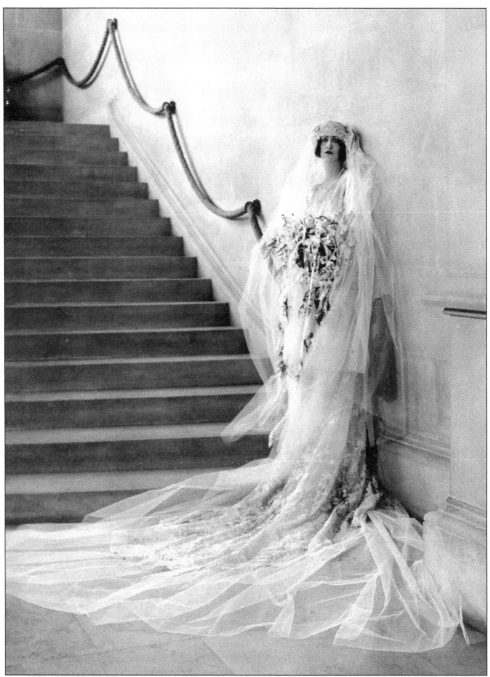

CORNELIA VANDERBILT'S FORMAL WEDDING PORTRAIT, 1924. Newspaper articles described Cornelia's long-sleeved bridal gown as being made of white satin with a four-foot long veil of tulle, which she wore during the marriage ceremony over her face. Orange blossoms from estate superintendent Chauncey Beadle's Florida home adorned the veil. Each of her white satin slippers was ornamented with a single orange blossom. A local florist created Cornelia's bouquet of orchids and lilies. For her formal bridal portrait, which was taken before the wedding, Cornelia posed at the foot of the Grand Staircase in Biltmore House.

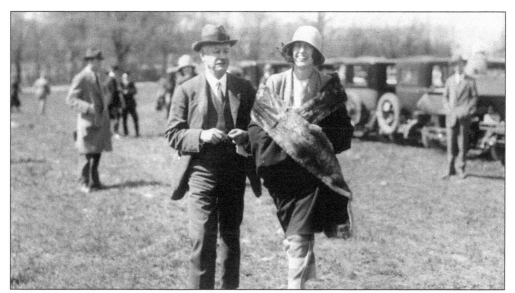

LORD WILLIAM CECIL AND CORNELIA VANDERBILT, APRIL 22, 1924. John Cecil's father, Lord William Cecil, arrived at Biltmore Estate 10 days before his son's wedding. Mr. Cecil's mother, the Baroness Amherst of Hackney, had died in 1919. In this photograph, Lord Cecil and Cornelia Vanderbilt are pictured at a society horse show that took place a week before the wedding.

HORSE SHOW, APRIL 22, 1924. Mrs. Vanderbilt hands out awards at the horse show, which featured riders from throughout Western North Carolina. Both Edith and Cornelia were accomplished equestrians and members of the Asheville Horse Show Association, which organized the event.

GUESTS ARRIVING IN BILTMORE VILLAGE, APRIL 27, 1924. Mrs. Vanderbilt sent hundreds of invitations to people around the world to attend her daughter's wedding. Among those invited were the ambassadors of Spain, France, Great Britain, and Italy; government representatives from Hungary, Denmark, Italy, Portugal, Czechoslovakia, Egypt, China, and Rumania; the dean of the diplomatic corps in Washington; and the U.S. ambassador to France. Guests stayed at the Grove Park Inn, the Kenilworth Inn, the Biltmore Forest Country Club, and at Biltmore House. In fact, over 60 guests were housed in Biltmore House alone, including the wedding party and close family members of both the bride and groom. In this photograph, Cornelia and Edith Vanderbilt laugh with Congressman and Mrs. John P. Hill of Maryland (on the left) and the Reverend and Mrs. Grenville Merrill and their two daughters, all of whom have just arrived at the Biltmore Passenger Station for the wedding. Mrs. Merrill was Edith Vanderbilt's sister Pauline.

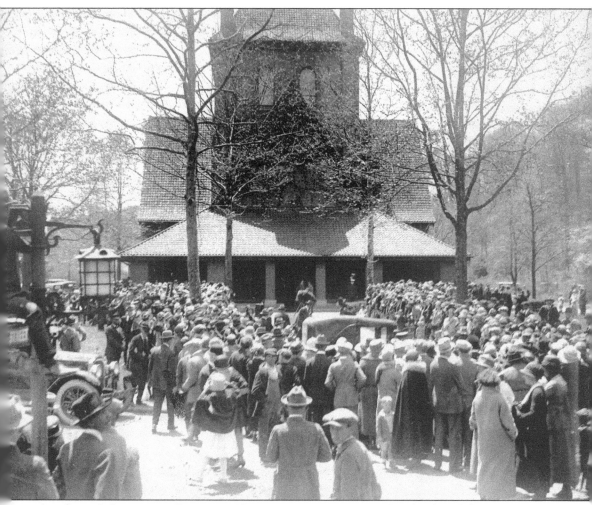

ALL SOULS' CHURCH IN BILTMORE VILLAGE, APRIL 29, 1924. On the day of the marriage ceremony, *The Asheville Citizen* captured the sense of excitement associated with the Vanderbilt-Cecil wedding: "The little English village conceived by the late Mr. Vanderbilt as an artistic addition to his extensive estate, Biltmore, was all aglow over the attendant ceremonies. Never before had such a distinguished group of people gathered there for such an auspicious occasion. The church was crowded with invited guests while hundreds of people lingered outside on the village green while the nuptials were being solemnized. Automobiles were parked everywhere and special police were present mingling with the crowds to direct traffic and maintain precaution against undue happenings." Notice the photographer perched on the lamppost on the left.

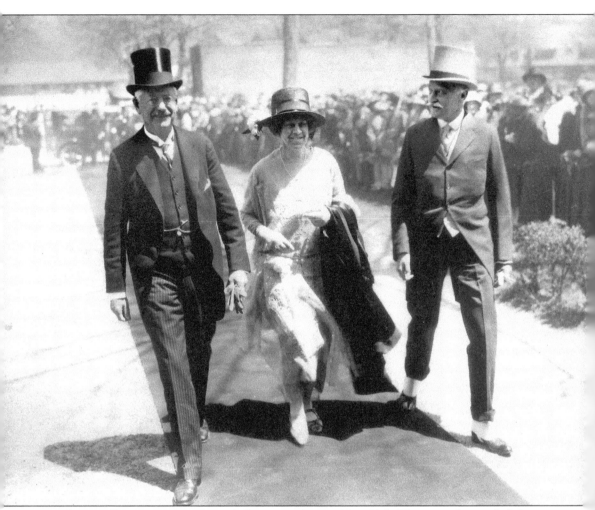

Guests Entering All Souls' Church, April 29, 1924. The guest list included many familiar names, including Astor, Waldorf Astoria, Condé Nast, Post, Pulitzer, Rockefeller, Churchill, Wharton, Lincoln, Roosevelt, Pershing, Taft, Coolidge, and, of course, Vanderbilt. Shown entering the church in this photograph, from left to right, are Lord William Cecil, Lady Florence Amherst, and Sir Esme Howard, British ambassador to the United States. Reporters seized the opportunity to publish elaborate accounts of the attire of prominent guests. The wife of the French ambassador wore black and white lace with an orange-lined accordion-pleated cape. Madame Riano, wife of the Spanish ambassador, chose a costume in brown and yellow with a black hat ornamented with a black and orange bow. Other costumes were ornamented with such things as ostrich feathers and flounces.

FLOWER GIRLS, APRIL 29, 1924. Local girls Peggy Morgan (left) and Jane Raoul (right), whose parents were Mrs. Vanderbilt's friends, served as flower girls. The girls were dressed all in white, with organdy frocks and straw bonnets, silk socks, and ballet slippers tied with satin ribbons. The eight bridesmaids wore gowns with skirts of soft green flowered Japanese silk and white bodices cut much like Cornelia's gown, with narrow, straight skirts. Because some of the flowers ordered for the wedding did not arrive on time, all of Cornelia's attendants carried bouquets cut from flowering shrubs on Biltmore Estate. Years later, Jane Raoul Bingham shared memories of her experience in an oral history interview: "Well, that was the highlight of my third grade, because my sister said I was utterly impossible! But I was so stuck up being flower girl. . . . We really thought we were pretty terrific. We really were." (Oral history interview, September 1, 1989.)

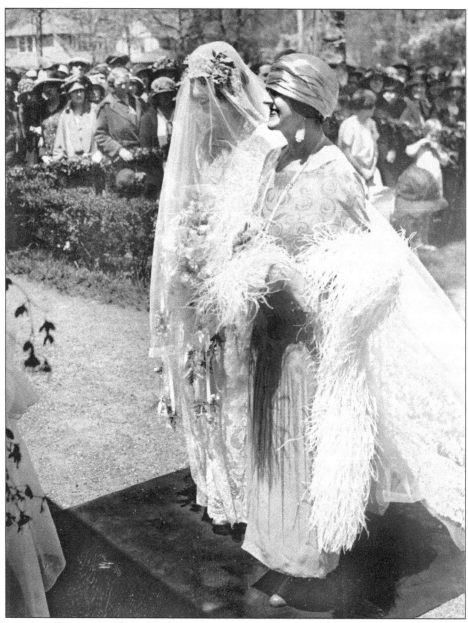

EDITH AND CORNELIA VANDERBILT, APRIL 29, 1924. Mrs. Vanderbilt escorted her daughter into All Souls' Church and down the aisle to the altar, where she gave her daughter in marriage to John Cecil. Mrs. Vanderbilt's dress was made of pale green and gold crêpe de chine. All Souls' Church was decorated with white dogwood blossoms, azaleas, and carnations. Two large palmetto palms towered over smaller palms in the sanctuary. An unidentified newspaper article noted that candles lent "a golden radiance to the beautiful flowery background of the sanctuary and brought out . . . the delicate beauty of the blossoms. The . . . flowers used in the church decorations came from the estate of the Vanderbilt family and their use added a delightful touch of sentiment to the occasion." New York organist Ernest Schelling played the *Lohengrin* "Wedding March" as the wedding party entered the church. Following the benediction, the All Souls' choir sang the "Seven-Fold Amen."

118

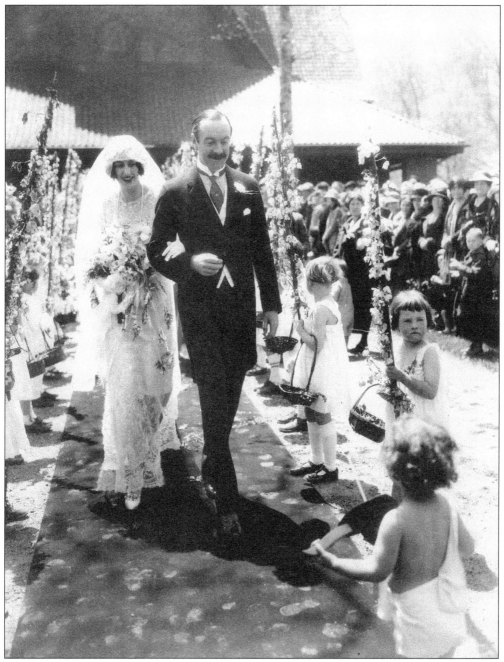

The Honorable and Mrs. John F.A. Cecil, April 29, 1924. As the Cecils left the church, they were greeted by 44 children of Biltmore Estate workers who, in the English custom, formed a double aisle down the lawn. Over their heads, the children held crossed branches of flower blossoms to form an arch under which the wedding party passed. All the children were dressed in white. In the foreground being greeted by the Cecils with her back to the camera was the youngest of all, Polly Ann Fowler, dressed as cupid. The little girl to her right is Blanche McCrary, whose father worked with the Biltmore dairy herd.

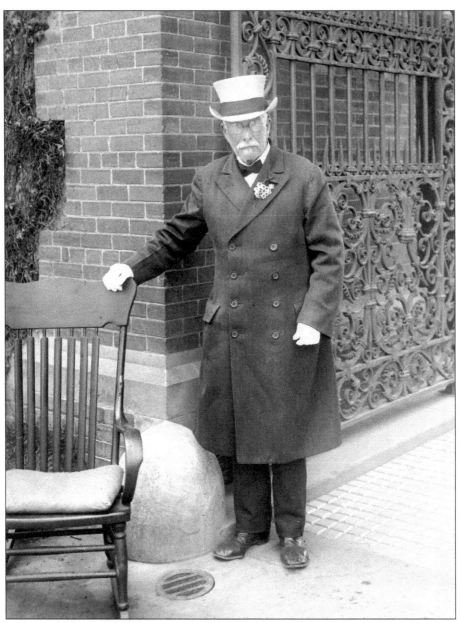

"OLD FRANK," APRIL 29, 1924. According to *The Asheville Citizen* on the day after the wedding, "Old Frank, gatekeeper at the Biltmore gate . . . was in all his glory yesterday. All his 37 years of faithful service at the entrance to the park were rewarded in one swoop. . . . A car ordered specially by Mrs. Vanderbilt took Old Frank and his wife to the Church . . . to witness the wedding of his young mistress to Mr. Cecil. No occasion could have caused greater joy to the faithful retainer and when the car, for him alone arrived, he was too overcome for words. A new coat was proudly worn by Frank, the gift of Mrs. Vanderbilt for the occasion." Estate workers and their families shared in many wedding festivities. The night before the ceremony, they gathered at dusk with lighted candles and lanterns. They approached Biltmore House quietly and then suddenly burst forth with whistles and other noisemakers. When Cornelia came out to greet them, they presented her with a complete fishing outfit and wishes for a happy marriage.

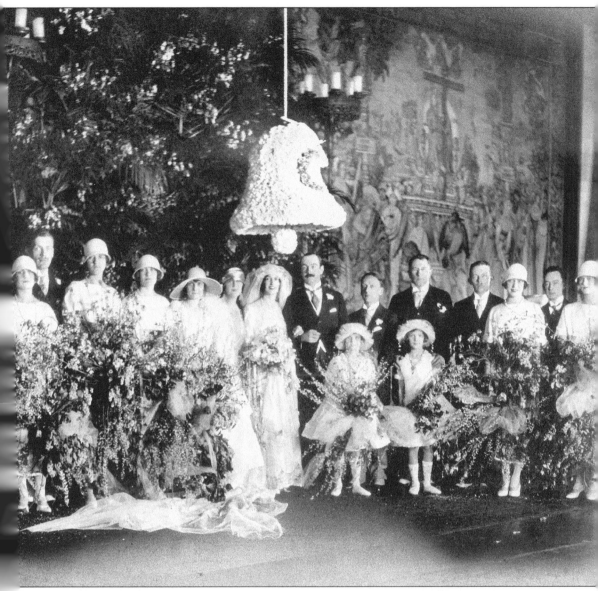

THE WEDDING PARTY IN THE BILTMORE HOUSE TAPESTRY GALLERY, APRIL 29, 1924.
Cornelia's maid-of-honor, wearing a wide-brimmed hat and standing next to Edith Vanderbilt, was Rachel "Bunchy" Strong, daughter of a Cleveland department store owner and a former schoolmate of Cornelia's at Miss Madeira's in Washington, D.C. Bunchy wore a bouffant-style white organdy gown with full sleeves and a large white hat adorned with a yellow arum lily. Mr. Cecil's best man, standing to his immediate left, was Hugh Tennant, a friend and colleague at the British embassy. The flowers placed in Biltmore House also came from estate gardens and included the floral bell composed of white carnations and sweet peas seen here.

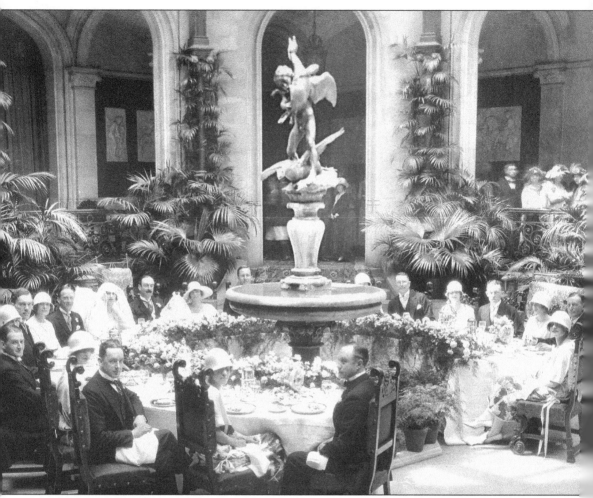

THE WEDDING BREAKFAST IN THE BILTMORE HOUSE WINTER GARDEN, APRIL 29, 1924.
Newspaper accounts recorded that close to 1,000 guests attended the wedding reception held in Biltmore House immediately after the noon ceremony. Two orchestras provided music for dancing, and then the bridal party gathered around a horseshoe-shaped table in the Winter Garden where they dined. Meanwhile, a buffet breakfast was served to other guests in the Banquet Hall. After the reception, Mr. and Mrs. Cecil drove to Mount Pisgah to spend a few days at Buck Spring Lodge. Along with streamers, their car was decorated with a pair of white slippers, the heels of which had been smeared with tar, a reference to Cornelia's nickname "Tarheel Nell." Following their stay at the lodge, the Cecils headed off to Europe for an extended honeymoon.

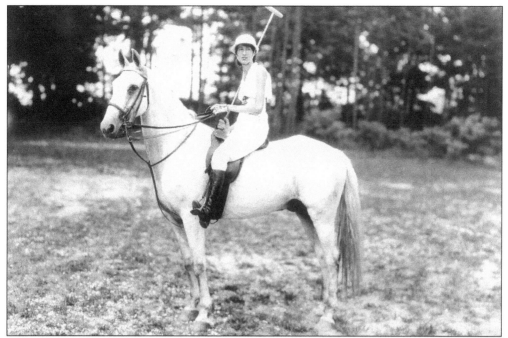

CORNELIA CECIL, C. 1925. After their honeymoon, Cornelia and John Cecil returned to Biltmore. As stipulated in her father's will, Cornelia took possession of Biltmore Estate upon her 25th birthday, on August 22, 1925. She and her husband made Biltmore their main residence and were active in local affairs. Cornelia was a member of the Biltmore Forest Bridle and Saddle Club and played on a local polo team.

JOHN CECIL, C. 1925. Aside from serving in England as minister of information for the British government during World War II, Mr. Cecil resided at Biltmore Estate for the rest of his life. He developed enduring relationships with estate residents who remembered him as a kind, down-to-earth gentleman. At annual Christmas parties, Mr. Cecil often portrayed Santa Claus, emerging from one of the vast fireplaces in the Banquet Hall with a giant bag of gifts over his shoulder, much to the delight and wonder of the children in attendance.

MR. AND MRS. CECIL AND FRIENDS, C. 1925. The Cecils entertained frequently at Biltmore Estate during the glamour days of the Roaring Twenties. They also maintained a residence in Washington, D.C., and traveled extensively. The local papers made much of their comings and goings and published extensive accounts of parties held at Biltmore. *The Old Asheville Gazette* noted in "Dateline 1925" that Cornelia's 25th birthday party was "among the most elaborate and largest celebrations held at Biltmore House since the establishment of the Biltmore Estate." It was an "open-air ball" to which over 300 people were invited. Guests danced while Charles Freicher's orchestra played, and Japanese lanterns hung from trees and shrubbery. Mr. and Mrs. Cecil (on the right) and unidentified friends are seen here on the terrace in front of Biltmore House.

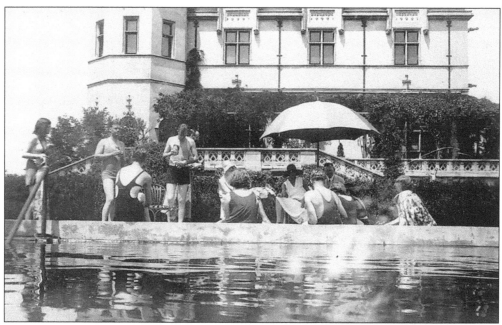

POOL PARTY, C. 1928. The original bowling green on the South Terrace was replaced sometime around 1920 with a swimming pool. In these images, the Cecils and their friends enjoy the pool during a summer house party. The swimming pool was removed in 1992.

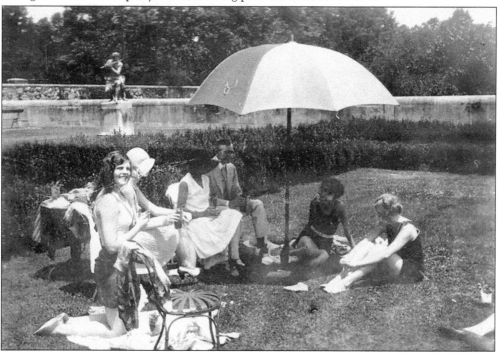

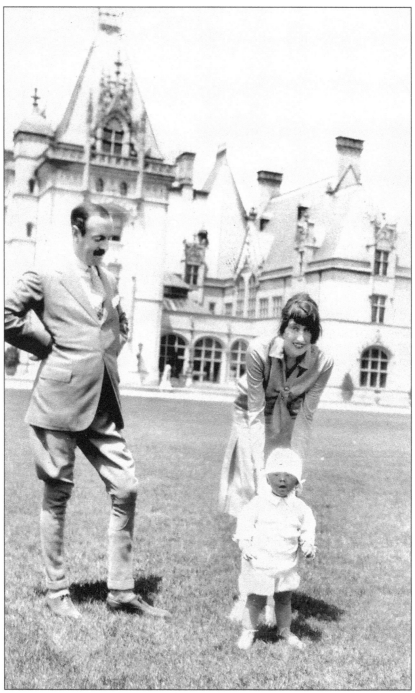

CORNELIA, JOHN, AND GEORGE CECIL, 1926. George Henry Vanderbilt Cecil was born in Biltmore House in 1925. After attending private boarding schools in England and Switzerland and serving in the British Royal Navy, he returned to Biltmore Estate. He was named president of The Biltmore Company in 1962, a position he retained for 17 years. In 1934, the Cecils divorced. Until his death in 1954, John Cecil spent the majority of his life at Biltmore Estate, while Cornelia Vanderbilt Cecil ultimately settled in England, where she died in 1976.

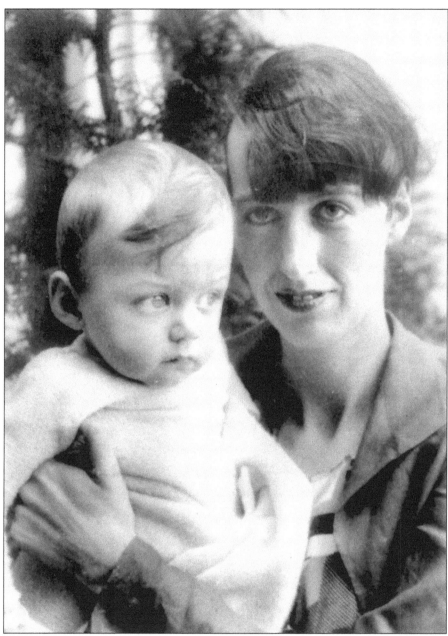

CORNELIA AND WILLIAM CECIL, 1929. The second child of Cornelia and John Cecil, William Amherst Vanderbilt Cecil, arrived in August 1928. Like his older brother, he attended schools in Switzerland and England and served in the British Royal Navy. After graduating from Harvard University and working several years for Chase Manhattan Bank, William Cecil returned to Biltmore Estate in the late 1950s to co-manage the estate with his brother. George Cecil focused his work on the Dairy while William managed the historic house and grounds. The brothers formally split the company in the late 1970s, with William Cecil retaining ownership of Biltmore Estate and George retaining the Dairy and significant land holdings. George Cecil sold the Dairy in 1985. Biltmore Estate is still privately owned and operated by William Cecil and his descendants.

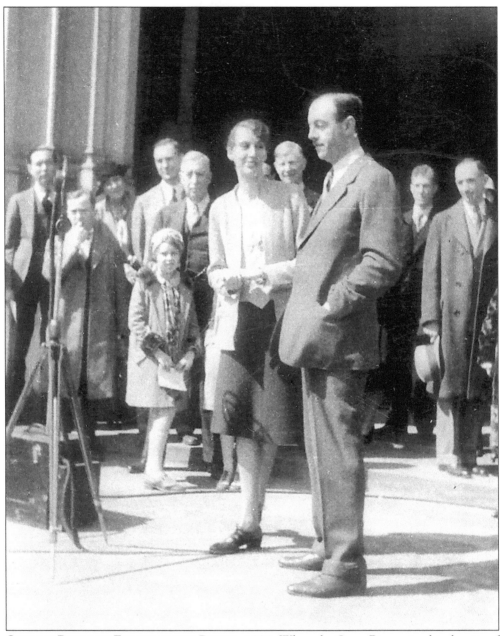

OPENING BILTMORE ESTATE TO THE PUBLIC, 1930. When the Great Depression hit the city of Asheville, leaving it with the highest per capita debt of any municipality in the United States, town leaders asked Cornelia and John Cecil to open Biltmore House to the public to encourage tourism. On March 15, 1930, the first paying guests entered Biltmore House. Cornelia Cecil spoke the following words at the opening ceremony: "Mr. Cecil and I hope that through the opening of Biltmore House to the public, Asheville and Western North Carolina will derive all the benefit they deserve and the people who go through the house will get as much pleasure and enjoyment out of it as Mr. Cecil and I do in making it possible. I also want to say that we both feel that in doing this, it is a fitting memorial to my father. After all, it was his life's work and creation."

Lightning Source UK Ltd.
Milton Keynes UK
UKHW030229041220
374592UK00006B/610